2012

The Speakeasies *of* 1932

GLENN YOUNG

BOOKS

The
Speakeasies
of 1932

AL HIRSCHFELD

Text
GORDON KAHN & AL HIRSCHFELD

Introduction
PETE HAMILL

GLENN YOUNG

BOOKS

A GLENN YOUNG BOOK
THE SPEAKEASIES OF 1932

© 2003 Estate of Albert Hirschfeld

Original version published in 1932, as *Manhattan Oases,*
by E. P. Dutton & Co., Inc. © 1932,
renewed 1960, Estate of Albert Hirschfeld.

Al Hirschfeld is represented by Margo Feiden Galleries Ltd., New York

Publisher's Cataloging-in-Publication Data

Hirschfeld, Al.

The speakeasies of 1932 / Al Hirschfeld ; text: Gordon Kahn & Al Hirschfeld ;
introduction: Pete Hamill. —1st Glenn Young ed. —
Milwaukee, WI : Glenn Young Books, 2003.

p. ; cm.

Includes bibliographical references.

ISBN: 1-55783-518-7

1. Bars (Drinking establishments)—New York (State)—New York.
2. New York (N.Y.)—Hotels, taverns, etc.
3. Hospitality industry—New York (State)—New York—History—20th century.
I. Kahn, Gordon. II. Title.
TX950.57.N7 H57 2003
647.95747/1—dc21 0306

FIRST EDITION

10 9 8 7 6 5 4 3 2 1

Printed in Mexico

Associate Publisher:	Jacqueline Miller Rice
Jacket Design:	Tony Walton
Back Jacket Photo:	Louise Kerz Hirschfeld
Production Design:	Graffolio
Associate Editor:	Greg Collins
Publicity Director:	Kay Radtke
Printing:	Westcom Graphics
Image Refinement:	Kelly Hanson
Research:	Bob Ward

The publisher gratefully acknowledges the extraordinary assistance of
Louise Kerz Hirschfeld, Tony Walton, Sue Knopf, Richard Re, Helen Kim,
Victor Seitles, and The Museum of the City of New York

Original pen and ink speakeasy drawings by Hirschfeld
are housed at The Wisconsin Historical Society.

All inquiries concerning rights should be addressed to Al Hirschfeld's agent:
The Lantz Office, 200 West 57th Street, New York, NY 10019

GLENN YOUNG BOOKS
are distributed to the trade by:
HAL LEONARD/APPLAUSE BOOKS
7777 Bluemound Rd., Milwaukee, WI 53213
800-524-4425 Fax 416-667-7832

www.applausepub.com

Dedication

Gordon Kahn and I inadvertently chronicled the end of an era. The year after this book's original publication, 1933, Prohibition was repealed. The Roaring Twenties had already succumbed to the Depression. About the best thing you could say of the next few years was that people could at last cry in their beer legally.

You are very welcome, I'm sure, to all your critical reservations about this book, but let nobody dare say it was not well-researched. This may be the best damned researched book ever! Every single spécialité de la maison was tried over and over by my pal Gordon Kahn and me until we passed out testing it for our reading public. One part aged like old fine wine, and one part bathtub gin, our tome was something of an odd blend even when it made its wobbly appearance toward the end of 1932, a sort of bull and cocktail story, complete with a Drinking Man's Recipe Guide for the Fried—a cookbook for those not overly familiar with a kitchen.

Then as now, this book is about celebrating good times. It never would have come to light again but for the dedicated passion and impractical persistence of a few important people in my life.

I herewith lift a libation to each of them:

> … to my darling wife, Louise, without whom so much would have meant so little, a Waldorf Cocktail . . .

> … to Glenn Young, my friend with intelligent ink in his veins, A New Orleans Gin Fizz

> … to Robby Lantz, my guru in the land of Mammon, a Brandy Crusta.

> *L'Chaim!*

Al Hirschfeld
January 2003

Contents

Dedication
5

Introduction by Pete Hamill
9

The Speakeasies of 1932
19

Biographical Note on Gordon Kahn
93

Al Hirschfeld
and the Speakeasies
of New York

Pete Hamill

This is a wonderful book about a lost world. It is part social history, part artifact of urban archaeology, part simple reporting on the long history of human folly. The apparent subject is the New York speakeasy, captured in words and drawings by Al Hirschfeld and Gordon Kahn in the final months of the preposterous American social experiment called Prohibition. The true subject is the book's wider context: the invincible stupidity of those who embrace what George Orwell once called "the smelly little orthodoxies."

The gaudy saga of Prohibition has generated an extensive literature, of course, but in New York the story had a special, almost personalized vehemence. From the beginning, millions of citizens felt that the national movement to make drinking illegal was directed at cities in general, and New York in particular. Most New Yorkers believed that the anti-booze people were a combination of right-wing rural politicians, severe (when not addled) Protestant clergymen, and feminists who unjustly linked Prohibition to the just cause of women's suffrage.

Seen that way, the primary targets were immigrants, all those Irish, German, and Italian drinkers of whiskey, beer and wine, most of whom worked in blue collars. The secondary targets were those who tolerated them. These included Democratic politicians of the Tammany school, union leaders, brothel keepers, the burgeoning entertainment industry (including the branch devoted to big time sports), along with many otherwise disinterested people who believed all those notions about personal liberty that were codified in the Constitution. In multi-ethnic, multi-religious New York, the unwritten codes of personal tolerance were what made a civil society possible. Prohibition, alas, made intolerance the law of the land.

The new federal law — called the Volstead Act — went into effect at midnight on January, 16, 1920, a bitterly cold New York night that was tinged with melancholy. The first casualty of the law was the old-time New York saloon, a creation of the late 19th century, with its grandiose furnishings, sawdust on the floor, singing waiters, dancing girls, cigar smoke, extravagant meals and oyster bars. Some of these establishments had glittered from the Gilded Age onward: Sherry's, Delmonico's, Churchill's, Shanley's, and seemed essential to the life of the city. A rowdier clientele flocked to the great roaring joints along the Bowery and in downtown Brooklyn. These were places where all sorts of people had fun, and fun, of course, was one object of the

prohibitionists' most ferocious condemnation. For the bluenoses (as they were called) fun was another word for sin.

But within months, the city had adjusted. Many law-abiding people now thought it was their patriotic duty to drink. And so, as the big saloon vanished into history, the speakeasy was born. This book is about some of them. Many speakeasies were hole-in-the-wall joints, or basement apartments in brownstones, or storefronts with painted windows. In one of the buildings where I lived my Brooklyn youth, the ground floor was once a speakeasy frequented by, among others, the famous bank robber Willie Sutton. We loved the secret legend of the place, even though by our time the site had been turned into a mundane fruit and vegetable store. In Manhattan, some speakeasies catered to a society clientele. A few merged the older and snootier society people with those newly enriched by show business or the booze business. No matter what class of citizen found his or her own speak, their very existence proved that "the great experiment" was an utter failure. On the day Prohibition started, there were fifteen thousand drinking establishments in New York City; within a few years, there were thirty-two thousand — all of them illegal. As Will Rogers famously said: "Prohibition is better than no liquor at all."

But the stupidity of the law created enormous shifts in American society. Cynicism about idealistic goals became a permanent presence in the American

consciousness. Corruption was accepted as a kind of grease that humanized the puritanical rigidity of the law. More important, there were such vast possibilities for sudden wealth that disorganized crime began to organize itself, and a union of Irish, Italian and Jewish gangsters created what was usually called The Mob. Most had come from countries where the state — and its police — were a permanent enemy. Many had developed great gifts for survival on the margins of society, along with highly-developed talents for conspiracy.

Prohibition gave them a chance at the big jackpot. Their crime — supplying liquor to people who wanted it — was not considered a crime by most New Yorkers. To some citizens, the bootlegger became a romantic hero, the urban equivalent of the Western outlaw-as-hero. The bootlegger had courage, defiance, intelligence, a swaggering contempt for orthodoxy and his aura was captured forever in F. Scott Fitzgerald's splendid 1925 novel, *The Great Gatsby*. Refinements on (or vulgarizations of) this urban myth would soon be essential to American movies, and would last — as did the Mob itself — all the way to the *Godfather* movies of the 1970s. By that late date, of course, the Mob was out of the liquor business and into the heroin rackets (among many others), and the aura of romance was long gone. Still, the allure of the gangster remained powerful. In the 1970s, apprentice gangsters looked at the *Godfather* movies as if they were training films.

In 1933, after thirteen years, five months and nine days, Prohibition finally ended in complete failure. By then Wall Street had laid its famous egg, and the Great Depression was ravaging American life. There were more important issues facing American cities. One of them was hunger.

This book is a product of that era. Al Hirschfeld and journalist Gordon Kahn wrote the text, obviously based on their own intimate experiences in the speakeasies, and their writing is as full of affection as Al's drawings. Like all good books, it reflects its times, while freezing time itself. It also shows us that Hirschfeld and Kahn had the great good fortune to be alive and young while something large was going on.

• • •

Like many great New Yorkers, Al Hirschfeld was born somewhere else. The place was St. Louis, Mo. The year of birth was 1903. He spent his childhood drawing and drawing and drawing. His parents, Isaac and Rebecca Hirschfeld, saw that he had a gift and decided in 1914 to move the family to New York. In the nation's great metropolis, their gifted son would find an art school where he could develop his talents.

The Hirschfelds — including Al's brothers Milton and Alexander — settled in the upper reaches of Washington Heights, at the northern end of the island of Manhattan,

an area that was then still semi-rural. It must have seemed a long safe distance from the ghetto-like poverty of downtown Manhattan and very far from the unfolding slaughters of the Great War in Europe. After a few years, the Hirschfelds moved to an apartment near the Polo Grounds, where the New York Giants played their seasons. Al Hirschfeld was a good ball player, but he had other goals: he started taking lessons in sculpture at the National Academy, and at sixteen enrolled in the Vocational School for Boys on West 138th Street and Lenox Avenue.[1]

He was soon at work, making architectural reliefs for buildings, then moving on to the art departments of the new movie studios. At eighteen, in the second year of Prohibition, he was art director at the Fort Lee studios of the Selznick Pictures Corporation, and was encouraged to open his own studio. He did so (going into debt) and had nine artists working for him in a West 53d Street brownstone. It seemed too good to last, and it didn't. Most of the new movie companies had begun the trek to Hollywood, and after two years, Hirschfeld's studio went bust. He had only one solution to his dilemma: to draw himself out.

He was already an accomplished draftsman, but did not yet have a recognizable style of his own. But he began to work on mastering the difficult craft of caricature. The great stars of that craft were almost all in New York. There was the extraordinary

[1] See Clare Bell's essay: "The Alchemy of Ink: Hirschfeld's New York." *Al Hirschfeld's New York.* Harry N. Abrams. Museum of the City of New York. 2001.

Ralph Barton, whose simple drawings were as dense with character as any novel. An exuberant artist named John Held Jr. was immortalizing the flapper as a successor to the old Gibson Girl, her hair worn bobbed, her legs protruding from short skirts, her hip flask the epitome of what journalist Westbrook Pegler would call The Era of Wonderful Nonsense. Caricature graced the pages of all the city's major newspapers, and was a staple of the glossy magazines, most particularly *Vanity Fair.*

At a Harlem party hosted by Carl Van Vechten, Hirschfeld met the star of *Vanity Fair,* a young Mexican of extraordinary talent and intelligence named Miguel Covarrubias. They were almost the same age, and soon became friends, sharing tables in some of the speakeasies in this book, and eventually sharing a studio on West 42d Street. This experience was to be decisive.

"Miguel influenced me more than I did him," Hirschfeld later said. "At the time, I was more of a painter and a sculptor, but I was fascinated and very admiring of his way of drawing. His technique consisted of elimination and simplification. When I turned to caricature, I remembered the lesson I had learned from him."[2]

Hirschfeld began selling his caricatures. His early style derived in part from

[2] Adriana Williams. *Covarrubias.* Texas. 1994

Covarrubias, who established sculptural form with his bold, feathered use of blacks. In the drawings of speakeasies for this book, there are some lingering traces of the great Mexican caricaturist. At the same time, Hirschfeld's mature style is making its own appearance. In the linear city of New York, Hirschfeld can be seen here moving towards an art of pure line.

You can see the mature Hirschfeld style in the hands and face of Otto, at Zum Brauhaus, or the lonesome portrait of Bill at The Stonewall, and in the face of John at the Epicure. He had watched these men, perhaps discreetly sketched them from tables, and then took them back to his studio, for refinement by elimination and simplification. He had also studied the places in which they worked, defining them by the details of beer steins or cocktail shakers, signs and photos behind the bars, and today those details provoke the murmur of drinkers, sudden bursts of giddy laughter, and the sound of music. There had to be a lot of Bix Beiderbecke in some of the joints, but whenever I look at Hirschfeld, in these retrieved drawings and in the drawings made in the last months of his life, I hear George and Ira Gershwin.

That is, I hear the music of cities, the music that defined an era in New York. Hirschfeld had other ambitions: he twice took long sojourns in Europe to work as a painter, and was a contributor to such left-wing magazines as the *New Masses.* But he also loved the music

of New York: of its theaters, which would consume so much of his long life, of its dance halls, of the radio. In his greatest work, his line is possessed of that sense of surprise that we associate with jazz, while adding a very human lyricism. That's what the Gershwins accomplished. They were fed by the culture in which they and Al Hirschfeld were young, when African-American music filled the air, when the children of Jewish immigrants were making an American alloy of Europe and Africa that endures to this day. That music celebrated the American ideal, without waving any flags, and in the drawings that would keep coming to the end of the century and just beyond, Al Hirschfeld celebrated its existence too.

This book reminds us that in its heyday, the speakeasy was a forging ground, a place where issues of class and race could be submerged in the name of a larger goal: the simple good time. In these joints, painters and cartoonists often sat with playwrights and novelists, to be joined by teamsters and stage hands and yes, bootleggers. All learned from each other. And at some of the tables, a young man named Al Hirschfeld was looking at faces, studying postures and clothing and detail, looking for revelations of human character. In the best sense, the speakeasies were his university, and we are fortunate to have this book, where he shows us so many of the things he learned.

The
Speakeasies
of 1932

NOTE: Precise addresses for many of the speakeasies
have been inserted into the text within parentheses.

The Bath Club

What looks like a mob arriving for a soirée at the Van Momzers are just the Bathers swarming in for their bout with the flagon. Their motors are opened by a doorman, togged out in a gold brocaded uniform. Listen for his whistle, audible on West 53rd Street and follow the svelte sisterhood inside.

The foyer in the handsome three-story mansion (*35 W. 53rd St.*) is all marble and gold. Flunkies in droves. Hat boys who won't touch a coat, and cloak boys beneath whose station it is to handle a Borsalino.

Up a graceful marble staircase, to the left, is a dining room. Spacious and comfortable. An orchestra plays chamber music. Champagne corks pop discreetly.

The barroom is directly to the right. A colored pair whip to a movable piano and sing the latest airs. Old favorites too, for those who come to sentimentalize.

The barmen are three, young and spruce. Their chief is Philip, who has a personality that the house policy demands he subdue. His conversation is limited to only the briefest pleasantries and murmurs of thanks.

A smattering of Park Avenue chatter and a flash of Paquin gowns. Black pearls in shirt fronts, and "mirabile dictu!" real evening pumps on the males. All of which isn't proof that the baser bloods can't seep in. There are chiselers, not recognizable at the first glance, but spottable after a while.

Private rooms for business conferences, unbusinesslike conferences, backgammon and contract on the third floor.

The headier drinks are a dollar, which takes in the cocktail category. The wines are listed up to $40 the magnum and may be trusted.

Beer? *Pul-lease, M'sieu!*

Philip Recommends:

TOM AND JERRY (HOT)

Use eggs according to quantity desired. Separate yolks from whites. Beat whites to a stiff froth. Beat yolks till thin. Add a teaspoon of sugar for each egg and mix together, stirring constantly. Put two tablespoonfuls of this mixture, a glass of brandy, and a glass of Jamaica rum in a tumbler, fill with hot milk and stir well. Grate a little nutmeg on top and serve.

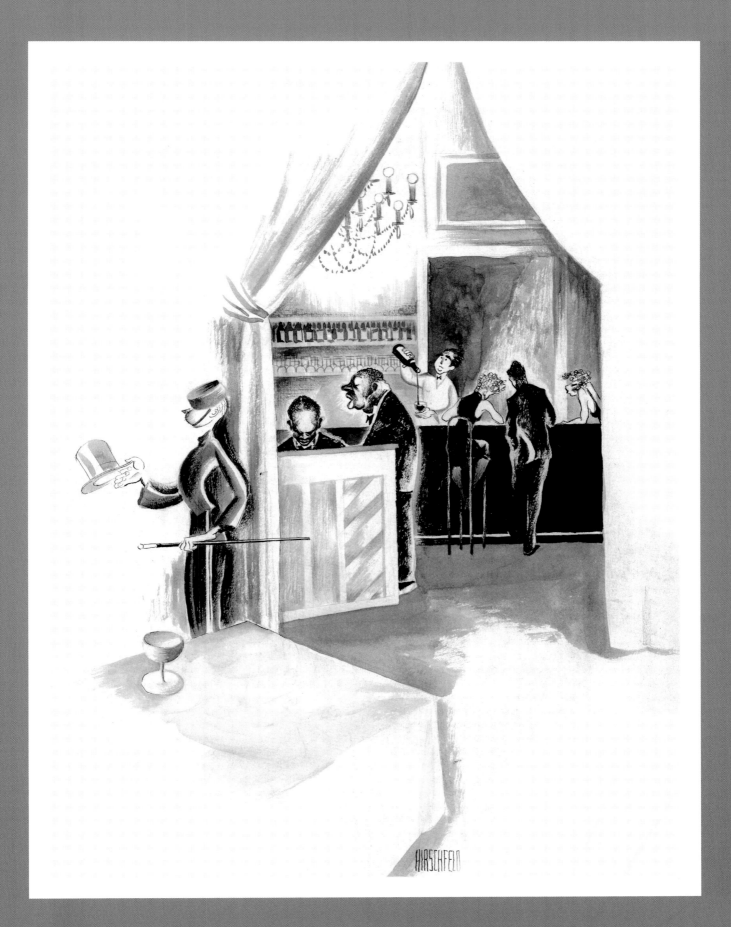

Philip

O'Leary's on the Bowery

Expect nothing too luxurious. The Brothers O'Leary strive to please, but the looms have delayed sending their brocaded draperies. Your indulgence, please.

Not so the squeamish, in stomach and nostril, for the sight and smell of a score of sodden derelicts is none too pleasant. They're not panhandlers or hoboes. They're just bums. They beg for pennies from the journeyman moochers who brace citizens for a "dime for a cuppa coffee."

The O'Learys pay no protection, yet it is doubtful if they can even show a small profit at the end of a week. It takes a lot of soup to feed their lousy flock.

Everything in this place on the Bowery is free—the thick soup, and enough hard floor in the back room for a flop; the thick hand-rolled cigarettes—everything but the booze.

Three fingers of powerful, reeking white liquid is a nickel. See them count it out with gnarled fingers on the zinc bar, as slowly as it they were parting with rubies. There's "beer," too, brewed somewhere in the neighborhood. That's ten cents.

O'Leary the elder was once a champion in the ring. He'll tell you about the time he knocked out Stanley Ketchel. He'd rather not talk about the bums he and his brother are feeding. There they are, look 'em over. Don't pity them. Don't expect gratitude if you order drinks for the house. You'll get snarls and black looks.

Gaunt John the Baptist, unkempt, snaffle-toothed, and ugly, will crouch over the battered piano and play anything, from any musical show in the last 40 years, including the entire Gershwin album and the Cole Porter songs. He shakes his matted hair over his eyes, looking nowhere but at the piano. It's a nameless fear, not shame.

A bum in the back room howls like a wolf in the night. Just an attack of the willies. Some bum booze he's drunk *elsewhere*.

John the Baptist begins playing "Meet Me in the Shadows."

"Good night, gentlemen. Sorry about them there drapes, ha, ha!"

Don't look back.

O'Leary Tempts with:

SMOKE

Dissolve two cans of Sterno in boiling water. Stir until lumps disappear. Continue boiling for 15 minutes, adding water to taste. While mixture is cooling tear cardboard shoe box in two inch squares and drop into liquid. This draws out any poisons supposed to lurk in the mixture. Remove cardboard after fifteen minutes, add a liberal pinch of tobacco for coloring. Let stand until cool. But for God's sake don't drink it.

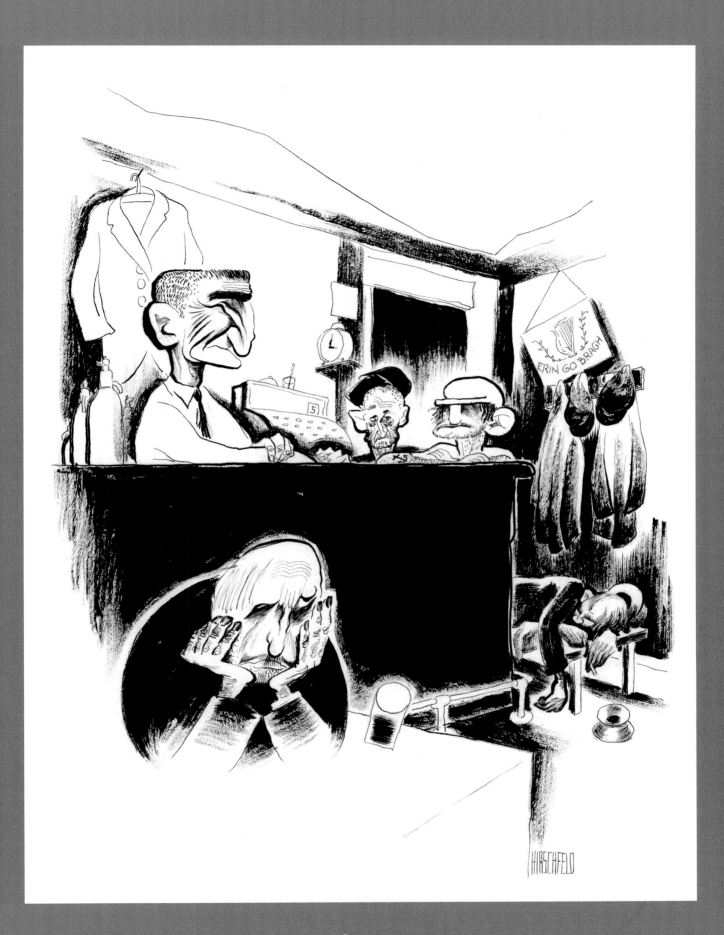

O'Leary

Jack and Charlie's

Be prepared to fight if you don't agree with its habitués that it's the best place in town. An unbiased estimate would be: second to the Mansion, also described in this volume.

Look for it on West Fifty-second (*21 W. 52nd St.*), within hearing of the Radio City babel. An example of what decorative restraint, spaciousness, excellent cuisine, and nonpareil beverages will do for a place.

Cards of admission are extant, but instant and unembarrassing admittance without one. A walking stick over the crook of the arm will serve to counteract an elk's tooth or tan shoes worn with a blue suit.

Bill is the bartender. A pleasant, agreeable fellow never guilty of making a drink taste too watery or too strong.

Frequented by writers of the better order; the cosmopolite; the men who go to the nearby picture galleries; understand Matisse, Ravel, and Ernest Bloch; who know "canard à la presse," drink hock, and call for their whiskey by name.

The cuisine is a happy wedding of the British and French. A five-dollar bill will see you through on the meal check, but you'll resolve to go for a ten the next time.

The bar is spacious, comfortable, and meticulously operated. The back-bar is sightly with statuettes of the White Horse whiskey steed himself and the Nicolas porter you've seen on the Continent. The beer steins on the mantel weren't turned out in gross lots either.

Probably the only place on the island where you can call for Dewar's, Teacher's, Walker's Black Label, or any other brand of whiskey and get just that.

Thank me.

Bill Suggests:

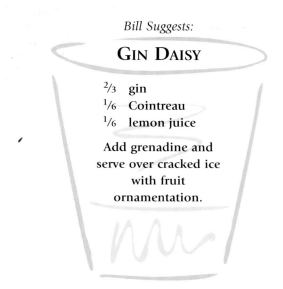

GIN DAISY

²⁄₃ gin
¹⁄₆ Cointreau
¹⁄₆ lemon juice

Add grenadine and serve over cracked ice with fruit ornamentation.

Bill

Zum Brauhaus

A fine old beer-and-eating place that's gradually succumbing to the tourist canker. Never been raided and probably never will be. A slower, more painful death awaits it at the increasing custom of rich vulgarians from West End Avenue and slobs from Broadway.

Only beer, and an eminently drinkable stein at a quarter is sold at the bar. Same price and same brew at the rough board tables, glistening with "schmaltz" rubbed in by the elbows of two generations.

Otto is the boniface and bartender. He hires no waiter who can't pick up ten heavy steins full to the brim in each hand and carry them to the farthest table.

The bar of ancient and staunch make, not any of your imitation mahogany makeshifts. The original lighting fixtures, which had gas jets in case that new-fangled electric lighting system failed, are covered with tinfoil in the summer to keep flies from fouling the oxidized copper finish.

The cuisine is utterly German and, in the Teuton tradition, four women do the cooking. The "Bauernwurst" is delicious. A crisp jacket which splits with a crackle and oozes a luscious "Zaft." Pigs' knuckles bedded in sauerkraut—the real sauerkraut that has caraway seeds in it. The steaks are prime, but cooked in the German fashion unless you order them broiled.

Old customers of Otto often bring their "Frauen und Kinder" in for a schnitzel or a veal tongue, and little August gets a slap across the side of the head if he didn't drink all his beer.

A wholesome place *(239 E. 86th St.)* that will merely amuse anybody under 30 but will bring a nostalgic pang to those who knew the old times and the old customs.

Otto Endorses:

BEER—5 GALLONS

EQUIPMENT: 6 gallon earthenware crock, sugar spreader, syphon, strainer for end of syphon, bottle capper, caps and bottles; a batch—which consists of one can Hop Flavored Malt Extract, 2 pounds brown sugar, and one yeast cake.

RECIPE: Boil one gallon of water and let settle, then add Malt Extract and sugar stirring well. Put this in earthenware crock and add four gallons of cold water. Dissolve yeast cake in glass of tepid water and add this to mixture. Let stand for three days, removing the foam twice a day. You are now ready for bottling. Put ½ teaspoonful of sugar in each bottle, pour brew into bottles through syphon, cap and then stand them upright for three weeks.

Otto

The Dizzy Club

Incorporated in 1923, the Secretary of State refused at first to countenance an organization with so flippant a title. It finally became a "societé anonyme" as the Disney Club. It's in the Fifties west of Sixth *(64 W. 52nd St.)*.

The Club motto is: "A rolling tomato gathers no mayonnaise." Other epigrammatic daisies on the wall state that when Anthony entered Cleopatra's tent he didn't go there to make a speech; that many a man found in pajamas was not always asleep and that paying alimony to a wife is like buying oats for a dead horse.

Over the bar is this cabalistic placard: W.Y.B.M.A.D.I.I.T.Y. The newcomer regards this for a while and then asks the barkeep, "What does that mean?"

"Will you buy me a drink if I tell you?" answers the barman. Sometimes the gag goes over, but more often not.

Jack, the bartender, speaks with a heavy Litvak brogue and loves to show you his trick with the glass highball stir and a pack of Camels.

Alumni of Princeton still shudder as they recall that autumn night in 1925 when the floor of the Dizzy Club ran with academic corpuscles. It was then they heard, for the first time, the dread slogan: "Hit him again, he's collegiate!"

The music is by automatic phonograph, except when Al, the minstrel of indeterminate coloration, scents what he calls a music lover in the house. Don't toy with Al. He has knocked down a dozen customers for calling him a nigger. He claims he is Hindu and Aryan. He strokes his guitar and sings, "Pale Hands I Loved Beside the Shalimar." Females over forty bestow on him sighs and silken pajamas.

Lou, the owner, a former mounted policeman, doesn't know "Brandwein" from leopard-sweat. One of the few real gentlemen in his business.

Three o'clock is the official closing hour, but if you're around at four or five, Neal, the doorman, will tell you if there's anything going on or coming off upstairs.

Jack Submits:

SIDE-CAR COCKTAIL

$\frac{1}{3}$ Cointreau (triple sec)
$\frac{1}{3}$ brandy (Hennessy preferred)
$\frac{1}{3}$ lemon juice

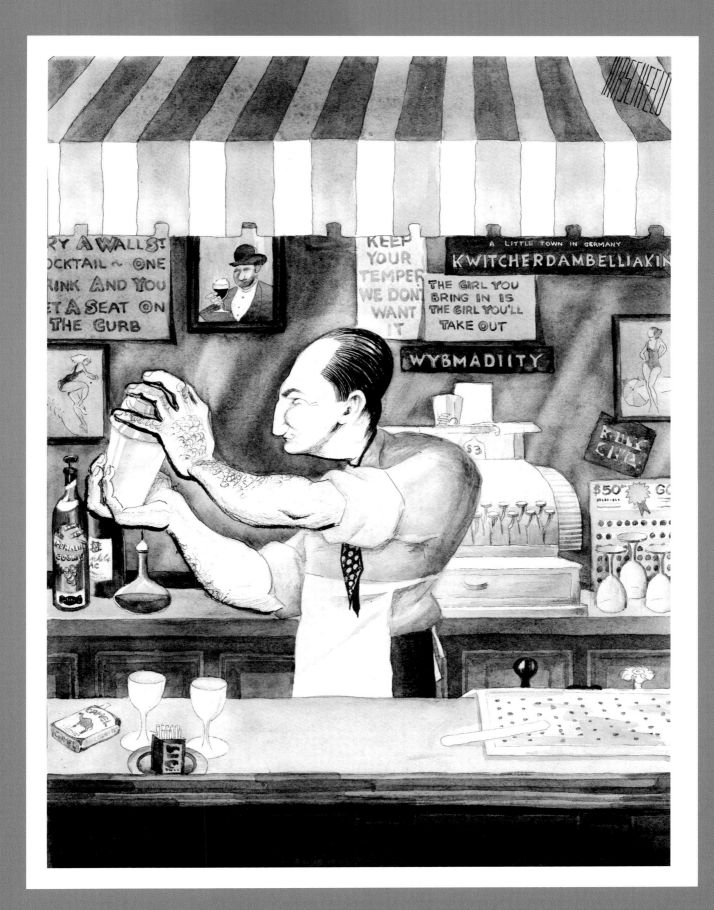

Jack

The Stonewall

Wrong. It's not on Jackson Street. It's in Greenwich Village, but not of or for it. So uniquely bold is the entrance that knowing that it's an alcoholic haven is the open sesame. No doorman and no silly questions. Walk right in and name your poison.

Bill, the barkeep, likes it that way. He's a funny old gentleman with a caustic tongue and a lash-like sense of humor. If his jibes at our times and customs, at Hoover and Mellon, fail to amuse, his skill as a juggler will certainly astonish. Why Bill never takes off his derby hat is none of your unprintable business.

The Stonewall occupies an entire low building of quaint design on lower Seventh Avenue *(91 Seventh Ave.)*. Downtown brokers and businessmen, taking that route uptown, stop their cars or cabs for a sudden one. It's even worth getting off at the Christopher Street subway station for a dram of the rye.

The interior is lined with rough-hewn logs. Assorted fish peep out from glass windows in the serpentine bar. Elks' heads with dandruff, sad-looking does, and an American eagle in mid-flight hang from the moulding.

There are comfortable booths on three sides of the large, square interior, but most of the bibbing is done at the bar, and for those who haven't leaned an elbow on a curved bar, this ought to be an experience. The ceiling is high, and the air is usually fresh.

The fire-waters are fifty cents and should command more from the exclusively non-Village trade. The suds are a quarter a scoop. The victuals are decently cooked, but nothing you'd care very much about.

The lah-de-dah blends, such as Alexanders, are confected, but none too cheerfully.

Bill Advocates:

ROYAL FIZZ

Yolk of fresh egg, one teaspoonful of grenadine, juice of ½ orange, juice of ½ lemon, one glass of gin. Shake well and strain into medium-sized tumbler. Fill balance with syphon.

Bill

Jack's

It has its hectic nights and its "off" nights. Scarcely a middle ground. Because its management is liberal, not because it's in Greenwich Village, on Charles Street, 'most anything goes. The less impecunious artists and writers whip themselves here into a stiff, alcoholic froth over the book or picture they are forever going to do.

The entrance is below-stairs in a brownstone building *(88 Charles)*. Booths line the wall. From these issue gurgles of well-necked women or sounds of violent quarrels. The general impression given by the place is that one is quite alone.

The barkeep is Jimmy, representative of the younger craftsmen. Polite, naïve when it suits him to be so, but all-seeing and all-knowing. His beer is a quarter and better than most of the slop in this neighborhood. The distillates are mellow, but their blandness disguises a vicious thrust.

The topers at the bar are those strong, silent drinkers who guzzle for hours on end, then quietly pay the reckoning and vanish into the night. They come day after day, for months always alone. Congenial stags they are.

On noisy nights there are delegations of bucks from the uptown universities who have come here because the address is easy to remember and they are paid no embarrassing attention. Their Oriental-looking women suck cigarettes and try to look as if they have lived life.

Lonesome men or those on the loose needn't remain that way if they don't object to a feminine drinking companion. But it's surprising how many of Jack's patrons do.

A good place to begin a large evening, but never, never the place to end one.

Jimmy Prescribes:

VERMOUTH COCKTAIL
Two dashes of angostura, two dashes of orange bitters, two dashes of grenadine, $\frac{1}{2}$ glass of French vermouth, $\frac{1}{2}$ glass of Italian Vermouth. Shake well and strain into cocktail glass, and squeeze lemon peel on top.

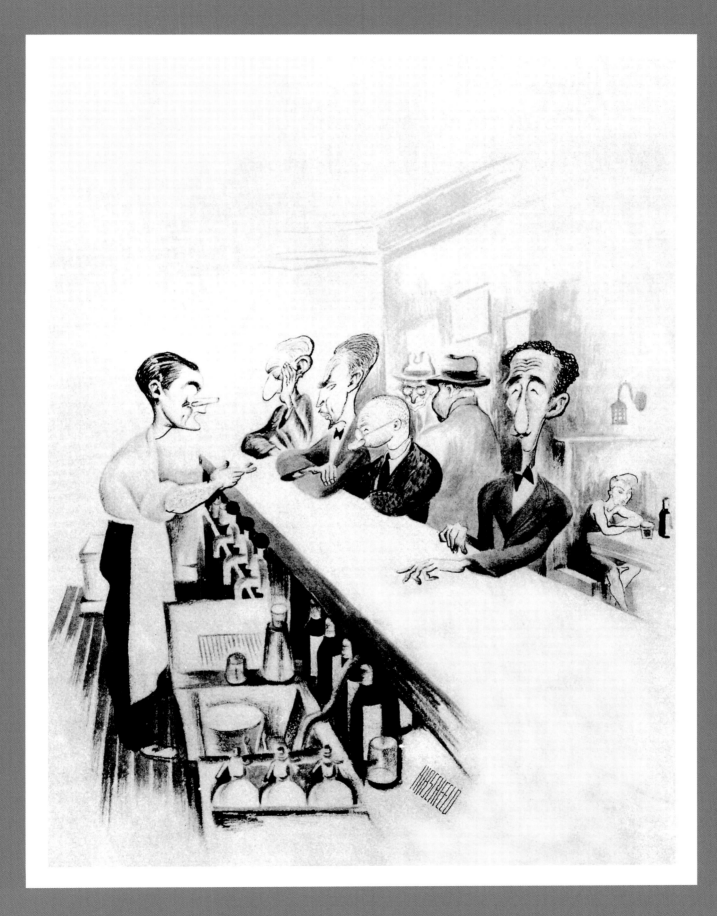

Jimmy

The Epicure

Overflunkied, with a small army of fawners. An acre of upturned palm which must be salved with no metal baser than silver. Carpets that feel like stepping on a club sandwich.

Seek a white stone house in the East Fifties, off Fifth *(40 E. 52nd St.)*. Raccoon coats are poison to the doorman. But occasionally there is a detachment of younger booze-punishers. Hilarious drinkers who dance with a feline crouch to the engaging stop-time of a first rate coon orchestra.

The more scholarly drinkers stick to the upstairs bar. The barkeep, like Simon called Peter, is John called Nick. He knows his manual. The festive mahogany is well equipped. Cognac, as slick as gun-oil, is decanted from a two-gallon magnum which sits in a stand on the bar. It's a dollar, as are the other hard drinks. Cocktails, nicely mixed, are the same. The tariff holds for beer and ale, which are bottled.

"Politesse" obtains here, where the clientele includes substantial citizens who scan the *Economist* and sigh over the *Wall Street Journal.* Snacks and finger sandwiches within reach.

In the foyer, an aquarium in which a school of lethargic fish gulp in a way that inspires a heroic thirst in the beholder.

The viands, in any of the three dining-rooms are a fair match for Longchamps' comestibles, but higher in price. Much higher. No additional levy for service on the terrace.

No place for moistening the pipes with a quick one at tea-time when an apprentice keeps bar and the service is sluggish.

The atmosphere strikes the golden mean between the "sportif" and the stately; like the aura around a Tammany man in a high Civic place.

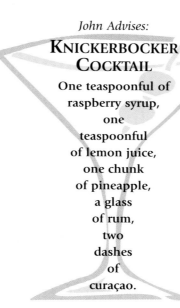

John Advises:
**KNICKERBOCKER
COCKTAIL**
One teaspoonful of
raspberry syrup,
one
teaspoonful
of lemon juice,
one chunk
of pineapple,
a glass
of rum,
two
dashes
of
curaçao.

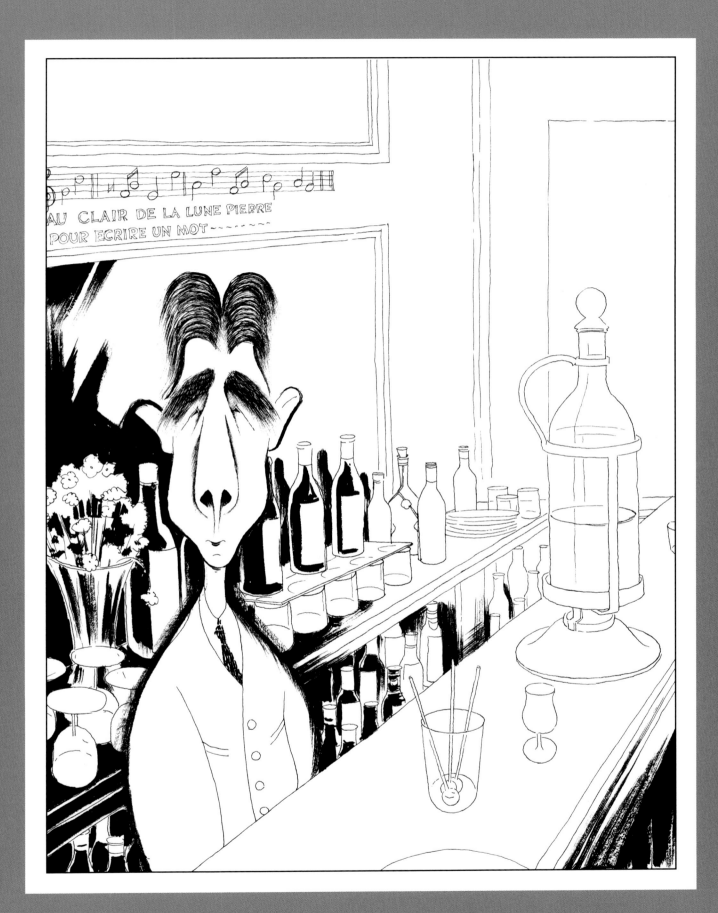

John

Club Simplon

No more solitary sighing after the delights of Zelli's and Florence's on the Right Bank. Come where there are others who will sigh and cry with you, mourn until the great Truth dawns that p'bish'n is a bleshing in dishguise.

Peter, the bartender, has that fishy eye with which "bistrot" proprietors appraise Americans. No offense to Peter, who's really nice and a practiced hand with his props.

Seek another water-hole unless you feel irresponsible and prepared to stand for any amount of kidding. Almost everything goes, but there will be no ghastly pranks like the administering of a Michael Finn.

Look for it in the Fifties, west of Fifth. The exterior is plain. Admission is not easy. Some questions asked. A nonchalant manner, with a touch of imperiousness, will get you by, here as elsewhere.

Collegians are automatically barred, unless they are in the company of, and vouched for, by a regular patron, who must be responsible for the stripling.

The people are nice, but apt to forget themselves once they go gay. The worst offenders are frequently the ladies. A pity indeed.

A dining-room adjoins the bar. Here some astonishingly good food prevails at prices that are a little too lofty to be fair.

The drinkables are of prime authority and reasonably well aged. The tariff for the stronger waters is a dollar straight, with cocktails the same. Beer, in bottles similarly taxed, but not a whit better than the average two-bit fluid.

Three of Pete's stingers and a man is ready to tear up his passport.

Pete Nominates:

WALDORF COCKTAIL

One chunk of pineapple,
one teaspoonful
orange juice,
1/3 French vermouth,
2/3 Italian vermouth.
Shake well and
strain into
cocktail glass.

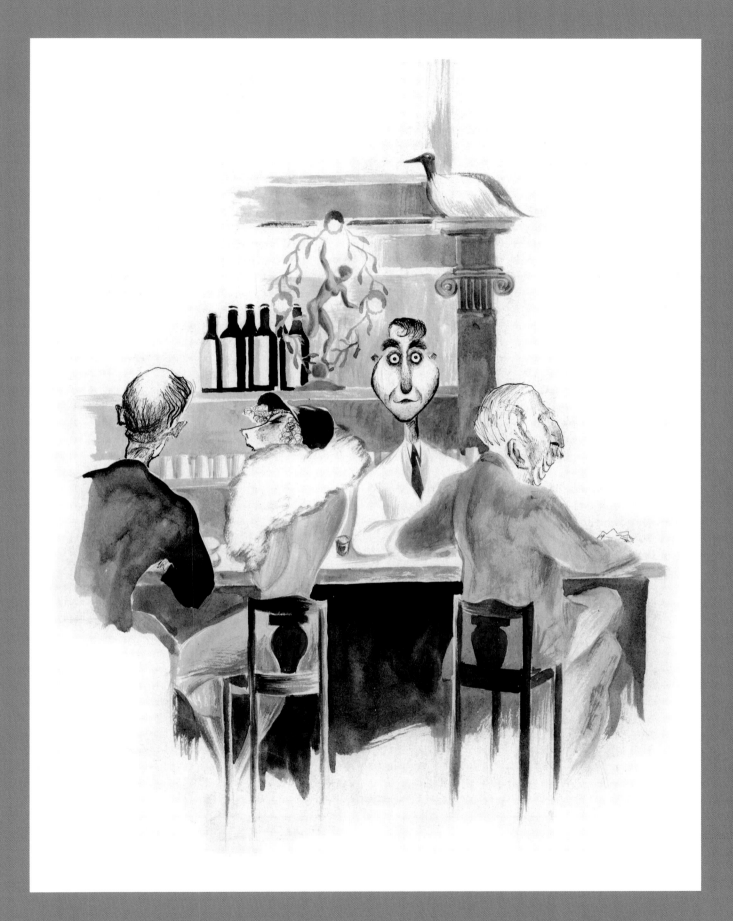

Pete

Bill's Bar

Time stopped here when McKinley was President; cocktails were two for a quarter; ten-cent cigars were made with tobacco, and spit wasn't a horrid word; Richard Carle was considered a great comedian; "skidoo" meant scram; carriage-striping was a fine art; covert coats and fawn-topped button shoes were proper male attire; spinach was a weed, and broccoli unknown.

Seek Bill's east of Fifth in the Fifties *(57 E. 54th St.)*. The street entrance is undistinguished, but the swinging halfdoors of a quarter-century ago lead to the main ballroom. "Bill's Place" is spelled out in silver dollars on a checkered composition floor. A silver dollar in every second square, and no amount of scuffing with the shoes will dislodge them.

Dan is the bar-man, and although a bit anachronistic with his surroundings, an efficient barkeep.

Currier and Ives prints of trotters in action and at ease; Century Wheelmen on their trim cycles; checkered tablecloths and oxidized copper lighting fixtures. The decorations are Buchanan's labor of love, or should be.

Dowagers are here, but they thaw out sufficiently after two Old-Fashioneds not to mind when the males remove their coats.

The menu is eclectic, with stress on the bulkier native foods. Good, but not commensurate with the tariff.

The straight liquors are a dollar, as are the cocktails, and both are of high frequency. Beer is from the wood, and ordinary at a half.

That cigar-store wooden Indian by the door may yet reach the Smithsonian Institution. It cost $4,500, and no fooling.

Dan Designates:

POUSSE CAFÉ
- ⅙ anisette syrup
- ⅙ cherry brandy
- ⅙ white mint
- ⅙ yellow Chartreuse
- ⅙ green Chartreuse
- ⅙ Grand Marnier

Great care
should be
taken
so as to
prevent
the different liqueurs
from running together.

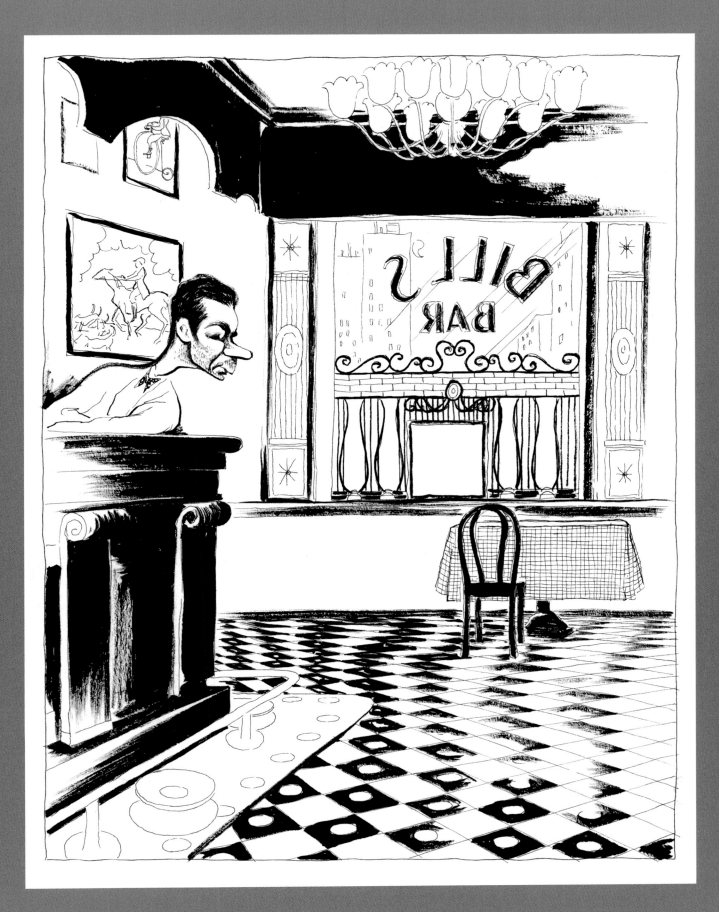

Dan

The Columbus Circle Club

A definite sensation that twelve years have slipped away taking their arid blessings with them comes with the first trickle of Irish whiskey down the gullet.

Not a speakeasy, not a clip joint, not a wine parlor, or a rum-foundry. Just a saloon, the sort of place into which snivelling, freckle-faced kids named Patsy may pop any instant with a demand for a growler of suds.

The last survivor of four similar places on a Ninth Avenue corner in the Sixties, it is going slowly, but gracefully, to pot. John is the barkeep and proprietor. He'll have no truck with the casual dilettante. He'll chat with none but his old customers, those who drank his beer when dapple-gray Percherons hauled it to the door at the dawn of the present century.

The telegraph ticker that did duty when Mathewson and Three-Fingered Brown played ball still chatters out the scores and the market reports. But nobody heeds.

The present habitués are humorless fellows with tight lips, who drink hard and swiftly, hate the law, and spit noisily into the bell-mouthed goboons.

The aging bar is still staunch and so true that dry glass will slide its whole length with a gentle push. The beer, though weak, sour, and obviously needled, gushes from a tap that gleams unashamed. It's a quarter a glass, and Bill is genuinely sorry that he can't syphon up some George Ehret's or uncap a bottle of Culmbacher.

The fifty-cent whiskey, either rye or Scotch, is high-proof, but of good age and accredited flavor.

Bill is hanging on in the belief that four percent beer is coming.

So is Christmas!

John Propounds:

NEW ORLEANS GIN FIZZ

White of one egg, teaspoonful of sugar, two dashes of grenadine, one glass of gin, juice of a lemon, 1/3 shaker of cracked ice and 1/2 wine glass of fresh cream. Shake for about two minutes, then strain into tumbler and fill balance with syphon.

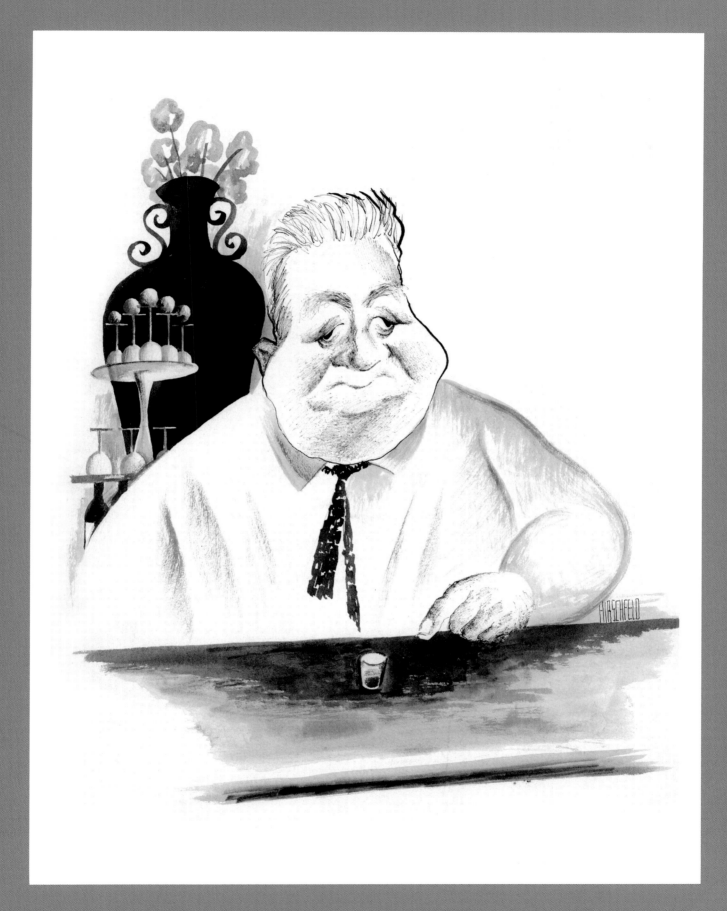

John

The Strollers

A well-patronized dining room, where nine out of every ten diners wonder why somebody doesn't make a speakeasy out of this place. They ought to have their noses operated upon. The bar is the first door on the south wall of the dining room. West-bound pedestrians can see it through a separate street door *(67 E. 59th St.)* and hear the waiters shouting, "Draw two!"

The soft-spoken gentlemen with blue jowls, hard eyes and "Barrymore" shirts have been mentioned in the prints as Public Enemies. They're often in amiable conversation with a policeman in full uniform. The remainder of the patronage numbers a handful of nondescripts who may be, and often are, race-track touts, gamblers and actors turned jewelry salesmen. It's where the Radio City construction dust is heaviest.

The barkeep is Mannie, who'd rather have a good cigar. He's amiable only when business isn't brisk.

Bar refreshments consist of the usual petrified pretzels, limp potato chips and a puzzling variety of cheeses crackers. All of it thirst-compelling.

A muscular white orchestra of five play a set program of numbers for the dancing. The music is as good as is deserved by the type who dance here. Paunchy Shriners and their peaked companions who can drink a longshoreman down in catch-as-catch-can or Graeco-Roman tippling.

The hard liquors are seventy-five, which is about what they're worth. The beer is a quarter and won't stand analysis for needling.

The dinner is a dollar and a half. To regular patrons, however, no check on Tuesdays.

Mannie Submits:

JOHN COLLINS

Put three or four lumps of ice in a large tumbler, juice of one lemon, two teaspoonfuls of sugar, one glass of gin. Fill balance with soda water and stir well.

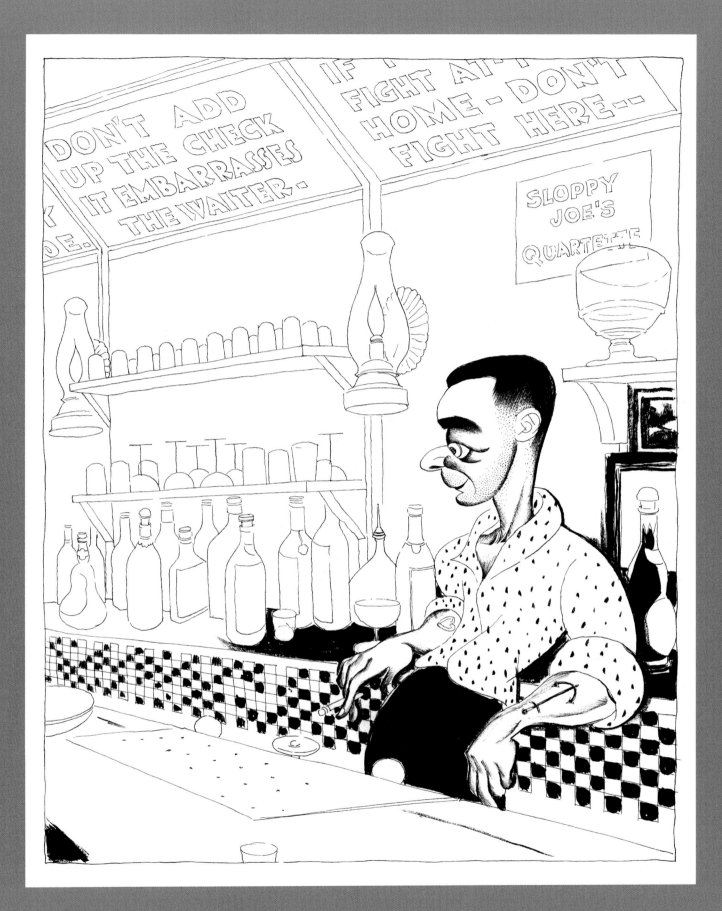

Mannie

The Tony's

Decidedly popular with that element of Broadway sophisticates for whom Heywood Broun does the thinking and the Algonquin the catering. A sprinkling of late white-haired boys from Columbia and City College who found they could write polysyllabic verse.

It's in the Fifties, off Fifth *(59 W. 52nd St.)*. Entrance is beneath the steps of the deadly, conventional brownstone house. Instead of a Tuscan who reeks with stale olive oil as a greeter, there is a lass in a French maid's costume who is just as redolent with chypre.

With few exceptions the women who frequent the place are sloppy drinkers. You can tell the hardier female guzzlers because they sit at the bar. The tyro drinkers think it's smart to stand with one foot on the rail.

Usually a representation of ladies on the loose at tea-time, and flirtations with them aren't difficult.

The bar is small, but complete. The brandy, fair. The Bacardis, good.

That sample of cloacal humor, called "The Bedtime Score Board," has no business hanging in the barroom. It belongs in some apple-knocker's backhouse.

Carlos is the bartender. A dull-witted Basque, he is slow on the uptake, uninspired in his work with the shaker and bottle.

Straight, hard liquor and cocktails are a dollar. Beer is of the bottled kind, and the tariff is the same as for the strong stuff.

The dining-room features an edible variety of Franco-American dishes.

The Tony's will stand at least one visit.

Carlos Presents:

BACARDI COCKTAIL
One teaspoonful
grenadine,
$1/3$ gin,
$2/3$ Bacardi
rum
and
the
juice
of $1/2$
a
lime.

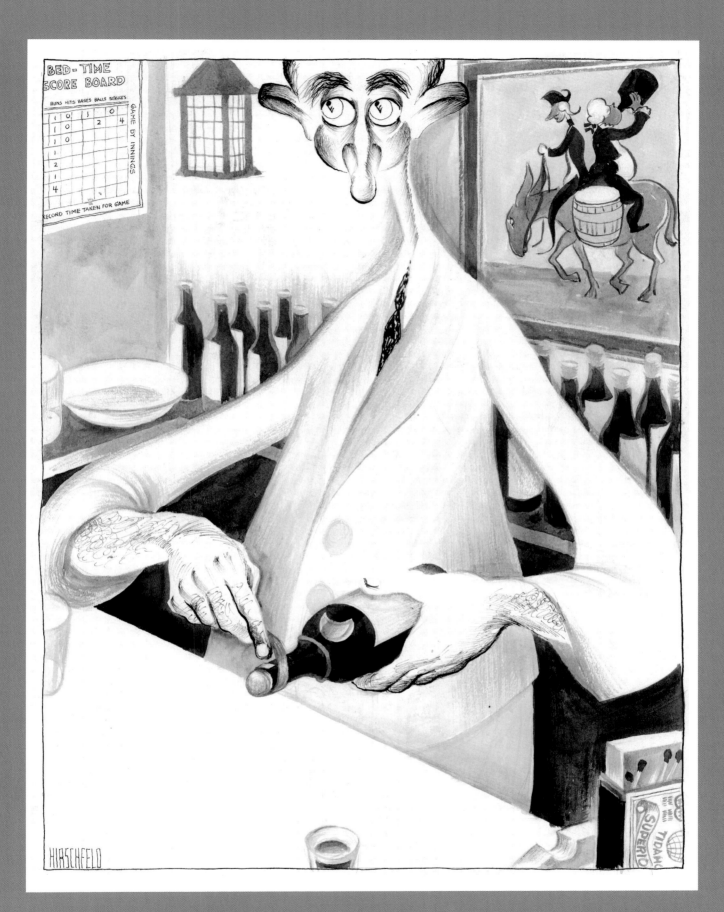

Carlos

The J and L

Operated for the benefit of men who will die sweet deaths from eating too much good flesh and drinking honest liquor.

The steaks are as thick as a telephone book and ooze a ruby goodness when stabbed with a fork. They're well worth the trouble of mounting a flight of wobbly wooden stairs to the second floor of a loft building in the West Thirties *(105 W. 38th St.),* and yanking open a fire door by main strength.

Not all cloak and suit manufacturers *spikking wid haccents* as you'll learn here. Phi Beta Kappa keys gleam on the well-tended stomachs of more than one of these good-humored dippers into the fleshpots.

The fodder is exceptionally good and the check is tempered with mercy. The waiters are diligent horse-players who always seem to pick winners. They make change from rolls that would choke a yak.

Frank the barman oversees a busy crew of three in a comfortable barroom apart from the main dining room. Why this establishment is always jammed with visitors from Boston is as much of a puzzle to your humble guide as it is to you. If Bostonians are all as pleasant as these, H. L. Mencken owes them an apology.

A patron here for the first time is asked for his card of admission. But the management has decency enough to wait until he has dipped his beak into the third or fourth drink. Only men are served at the bar.

Frank dispenses first-chop liquor at seventy-five cents. The beer, from the wood, is of a faintly soapy after-taste and is not recommended. The ale, on the other hand, is as good as any you drank in Montreal, but it's a dollar.

Those steaks!

Frank Proposes:

MANHATTAN COCKTAIL

One dash of angostura bitters, $2/3$ rye whiskey, $1/3$ Italian vermouth. Shake well and strain into cocktail glass with a cherry.

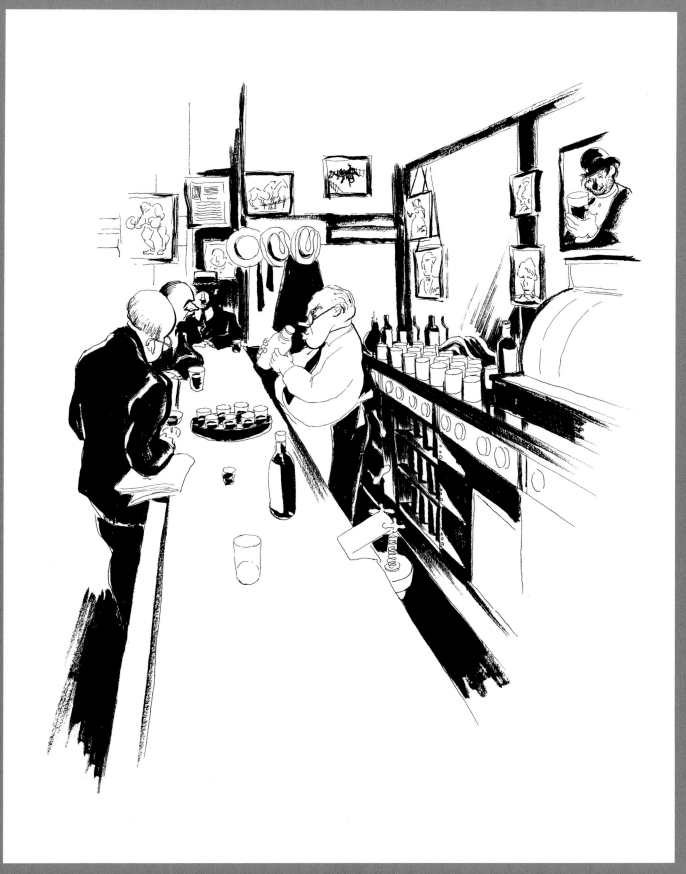

Frank

The Log Cabin

Designed for the visiting Shriner or the more simple native. Ideal for a rendezvous or a quiet conference among small groups of men.

In the Fifties, east of Seventh Avenue, above a garage. A rough, pine-bark railing to hang onto when coming down. The hewn log and rustic "decor" is carried out within, except for the furniture, which is wicker and much too large for comfort.

Two or three quiet waiters always on duty to bring drinks to the tables, for which service there is no extra charge. Occasionally one will forget that he isn't working in a joint and bellow his order.

The music is by radio. John is the bartender. Middle-aged and an old-timer in the profession. He'll befriend the first man who seriously asks him for a brandy crusta or a Prairie Oyster cocktail. The "Racing Form" occupies his entire attention between service of drinks.

The Ladies' Parlor is lit with dim red and blue lamps. Hushed conversations and quavering importunities in there. Occasionally the long moist smack of a beery kiss.

An aquarium with a dozen listless goldfish of the goggle-eyed variety are infected by the general lassitude of the place. They die after a couple of weeks.

Beer is a dollar, bottled and of the common variety, indistinguishable from the twenty-five cent stuff sold in many places. The hard liquor is drinkable, but not to be recommended except as well-watered highballs or extremely cold in cocktails. A bowl of peanuts is on the bar and at the tables. A keg of them is in the center of the room.

Customers must register. Those who haven't put in an appearance for long enough to be missed are subject to the follow-up letter which begins, "Dear friend" and refers to the Log Cabin as "your club."

John Offers:

PRAIRIE OYSTER COCKTAIL

Put two teaspoonfuls of Worcestershire sauce in a wine glass, add the unbroken yolk of a fresh egg, sprinkle with a little red pepper and salt and put two tablespoonfuls of malt vinegar on top. (For that "morning after" feeling.)

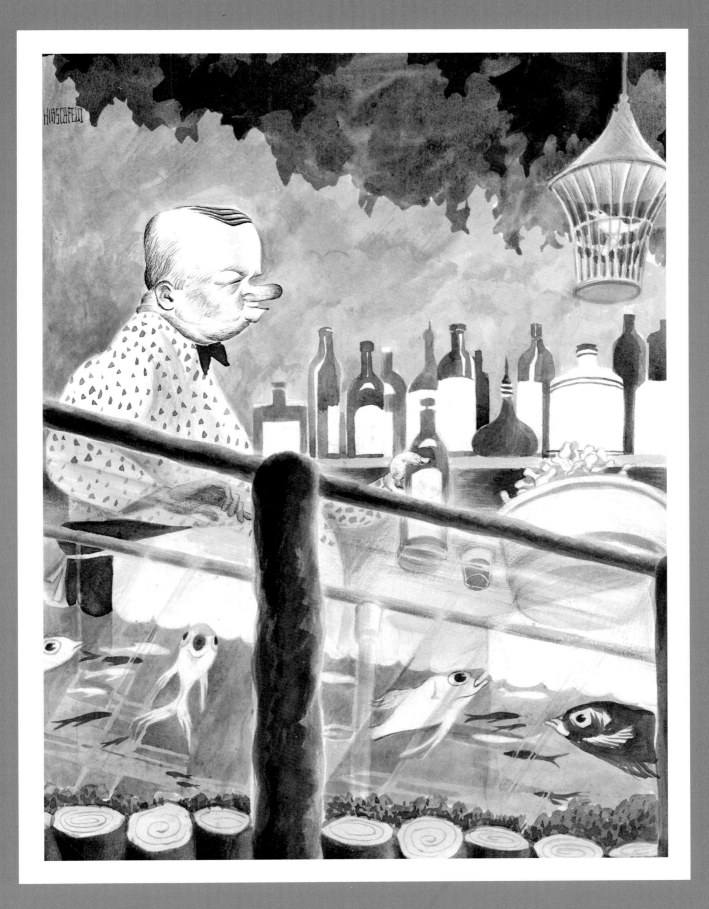

John

The Press Grill

The editorial annex of the largest of the tabloids. Here many an exclusive story is plotted and executed. Copy readers who drank themselves out of managing editorships look upon the red rye, curse it for what it has done to them, and still cursing, drink it.

In the Forties, west of Third Avenue *(152 E. 41st St.)*, such over-elaborate pains are taken to conceal the fact that it's a speakeasy, that it shrieks out there's whiskey to be had within. Entrance is directly from the street to a blind dining-room. Dun walls and a depressingly low ceiling. A short flight of stairs leads down to the bar, festooned with red-white-and-blue bunting, an automatic composograph picture of Lincoln, Washington and Wilson. The bar itself is of porous pine and somewhat warped.

The bartender is Bob. One of the new school. Most expert on rickeys and fizzes, but rather crude on cocktails, which may be due to the lack of the more refined beverages.

The beer is a quarter and packs an instant kick of short duration. Brief vertigo after three of them. The hard liquor is fifty cents, with the rye entirely too dark to be the McCoy. The Scotch is authoritative.

The patrons mostly newspaper men; the conversation almost entirely of shop or women. Occasionally advertising solicitors will come in and be tolerated by the more swashbuckling reporters. Drunks are seldom seen.

The free lunch is of the run-of-the-mill variety, plentiful but unappetizing.

Not exactly depressing, but far from exhilarating. Intolerable but for the presence of the news chaps.

Bob Elects:

GIN RICKEY

Put one lump of ice in a tumbler, cut a fresh lime in half and squeeze the juice in the glass, add one glass of gin and fill balance with seltzer or soda water.

Bob

Mike's

Not Harlem's challenge to the white crusaders. Merely an eloquent nose-thumbing at the efforts of the ofay meddlers who are trying to clean it up.

The entrance is on Seventh Avenue in the 140's and white merrymakers needn't feel too conspicuous. These bojangs hanging around the entrance have seen Mister Charlies and Miss Marys before, and some on their whispered comments are not flattering. Caucasian patronage is tolerated but not solicited.

The choosey drinking habits of the whites are a bad influence on the sale of "mule" to the dusky element.

The management is Negro, but the barkeep Ralph is white, as are the other executives in Mike's. The clientele has never heard of Carl Van Vechten and doesn't care.

Curfew is at three. But don't go. Follow the crowd out to the annex. Two doors away, down to the cellar. Tables are scattered inside and around empty coal bins. Watch your head or be brained by the low steam pipes. The bar is built of packing cases, and the source of water for washing glasses hasn't been discovered yet.

The hottest piano in Greater New York. The rowdy-dowdiest singers. One dollar if you want to hear "Potato Patch Blues," "Black-Snake Poppa," or any of the other purple songs.

The liquor is a colorless, limpid mixture of alcohol and distilled water, taxed at a quarter for whites and a dime to the Afro-American. Little flasks, containing under a half-pint, called "shorties," are available. The ginger ale is a bold mixture of seltzer, saffron, and capsicum.

There is good liquor, too, but that's only for the nigger sports and their lady friends. Sandwiches are disinterred from somewhere in the building.

Closing only when the last spajang customer leaves, regardless of the number of whites remaining in the place.

You'll come again.

Ralph Sponsors:

PINK LADY COCKTAIL

White of a fresh egg, two teaspoonfuls of grenadine, $\frac{1}{2}$ brandy, $\frac{1}{2}$ gin. Shake well and strain into cocktail glass.

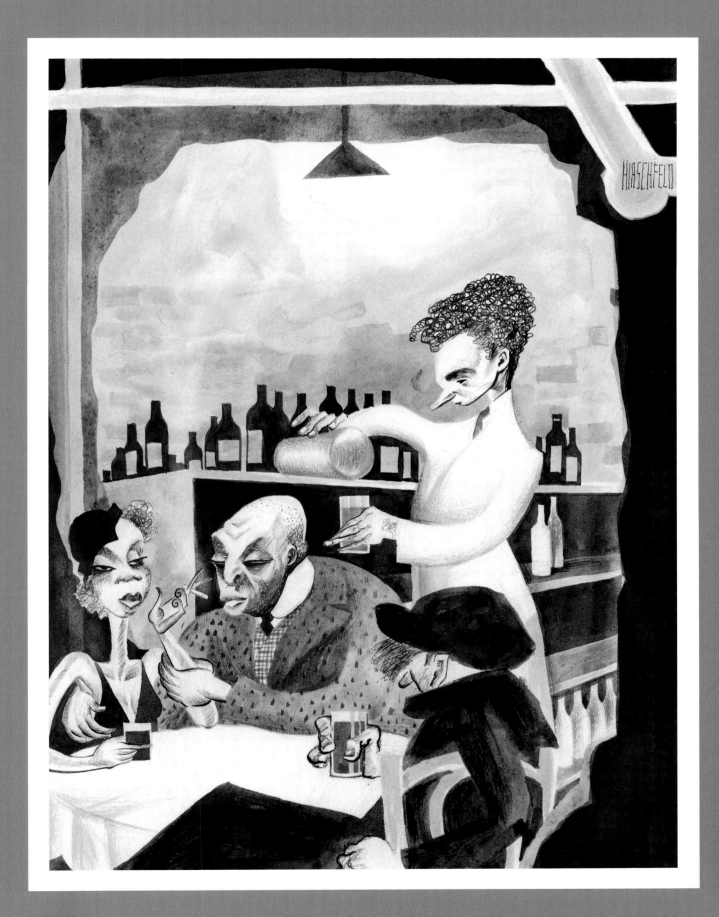

Ralph

The Mansion

The most pretentious place in New York, or it will do until the most pretentious place is built. Luxury and pomp with flunkies that work as fast and noiselessly as genii.

In the West Fifties, off Fifth *(27 W. 51st St.)*, it is a former banker's idea of the Lycée Palace. Admission is by a unique, wooden card only and these are distributed with caution.

The influence of the motion picture mosques is evident in the uniforms of the flunkies and their military deftness in handling the guests. The chandeliers, drapes and tapestries were installed by the original owner. But the furniture is new and reveals uncommonly good taste in its departure from the scrollwork and needlepoint era.

The first floor is a breathtakingly spacious entrance hall. A broad, graceful staircase leads to the second story. Here is the dining-room. A balalaika orchestra and a "prix fixe" dinner that's worth ten dollars at the Colony restaurant but which is assessed at two here.

Off this is the barroom, circular, spacious, exquisitely decorated. A marvelous but anonymous colored orchestra. The third and last public floor is given over to cards, ping-pong and backgammon.

Eddie is the chief of four barmen. All well-groomed, super-efficient and their manner is in keeping with the dignity of the Mansion.

Hors d'oeuvres and bridge-sandwiches served at the bar or tables. The clientele is sporting and theatrical. The cream of the municipal bureaucracy.

Beer or ale, if it's asked for, and served ungrudgingly. Drinks begin at a dollar.

One of Prohibition's greatest blessings.

Eddie Proffers:
BRANDY CRUSTA

Moisten rim of small
wineglass with lemon, dip rim
in powdered sugar, to give
glass frosted appearance, peel
rind of ½ lemon and put in
bottom of glass, then pour into
shaker one teaspoonful of
sugar or grenadine, three
dashes of maraschino,
three dashes
of angostura
bitters, juice of
½ lemon,
one glass
brandy.
Shake well, pour into
glass and add fruit.

Eddie

Julius'

A madhouse without keepers. As weird as a witch's Sabbath and as noisome again as the psychopathic ward at Bellvue Hospital. Withal, the best known place, without exception, in all of New York. Jammed to the squirming point every hour of every night. No prizes for being able to convey a drink from the bar to the lips one time out of three tries. There should be.

Once known as John and Andy's, but the personality of Julius, the former barkeeper, invoked the present gigantic following. The present incumbent is Tommy, who is young and a smart hand with the rubber socking-hose and bare fists when the occasion calls for some expert slugging. Which is often.

Four times padlocked, Julius' is (at this writing) back on its original Waverly Place corner in Greenwich Village *(159 W. 10th St.)*, for Villagers almost exclusively. Sensible citizens betray themselves by ordering anything else but beer. The strong waters are fifty cents with no guarantee that they will reach your face.

Six deep have stood up and been counted at the bar. It's to New York what the Café Dome is to Paris. And by that token, if you can stand to remain here long enough, everybody you ever hoped to see, and a lot you hoped you wouldn't, will come in.

Two Villagers splitting a glass of beer between them is no novelty. The brew is heavily needled and retails at twenty-five cents. The women turn hell-cat, and the men either sloppy or belligerent after three of four hours of indulgence in Julius' bought and filched beer.

How lovely, by comparison is a cool draught from a sewer after an hour in Julius'.

Tommy Counsels:

BRANDY FLIP

One yolk of fresh egg, one teaspoonful of sugar or grenadine, one glass of brandy. Shake well, strain into small wineglass, and grate nutmeg on top.

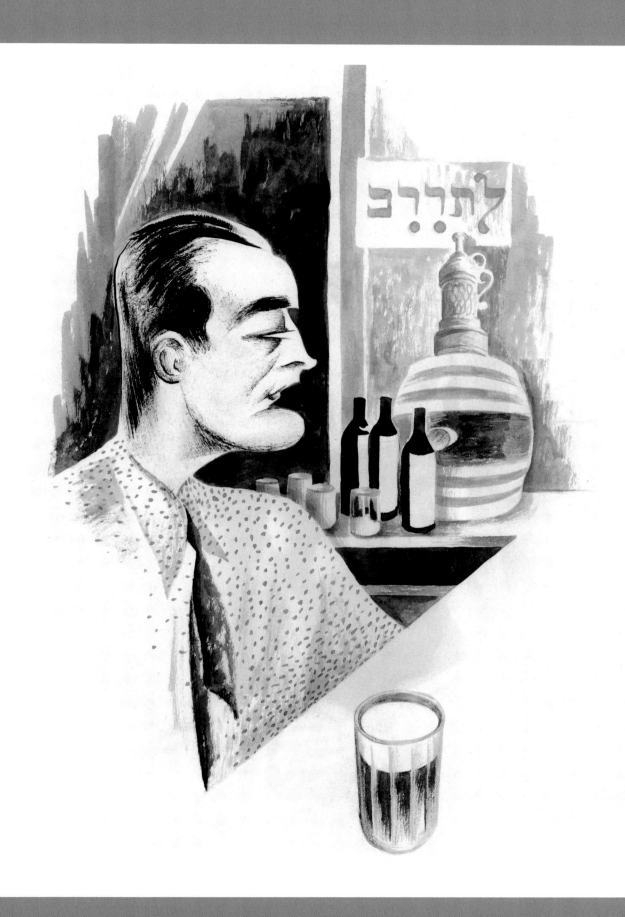

Tommy

Park Grill

The bar leading directly from the street entrance is a snare and a delusion. The uninitiated stop here and wonder why the beer is non-alcoholic and the bartender plays dumb when asked for anything stronger.

The real bar is upstairs in this "estaminet," which is in the West Fifties, near Sixth *(106 W. 52nd St.)*. If one is known and in a hurry, a dumbwaiter brings down the liquor from here to the blind bar below. A brief bit of hocus-pocus at the barred door before entrance is gained to the real upper bar. The room is long, the bar of generous proportions and reasonably well equipped. The decorations are atrocious, comprising imitation coats or arms. A picture of Al Smith and another of Jimmy Walker. Prominently displayed is the license for selling liquor, issued to Abraham Lincoln and a partner.

The regular clientele includes Broadwayites, with a representation of musicians and song writers. Social intercourse is not encouraged, as there are only two tables in the entire barroom. The place is tolerable only after the fifth or sixth drink.

Joe the bartender is an overly curious fellow. He is certain to know a mutual acquaintance of the newcomer and will consume every idle minute in asking about him and how things in general are going. If the customer is at all in doubt, Joe will tell him what's wrong with this country.

One of a chain of bars allied with a big brewer as an outlet for his medium grade beer. It's twenty-five cents a generous glass here and rather palatable. The whiskey, notably the rye, is potable. The cocktails are indifferently made. The free lunch is ordinary, with the exception of the potato chips which somehow are always fresh and crisp.

Joe Certifies:
ALEXANDER COCKTAIL
⅓ crème de cacao,
⅓ brandy,
⅓ fresh cream.
Shake well and strain into cocktail glass.

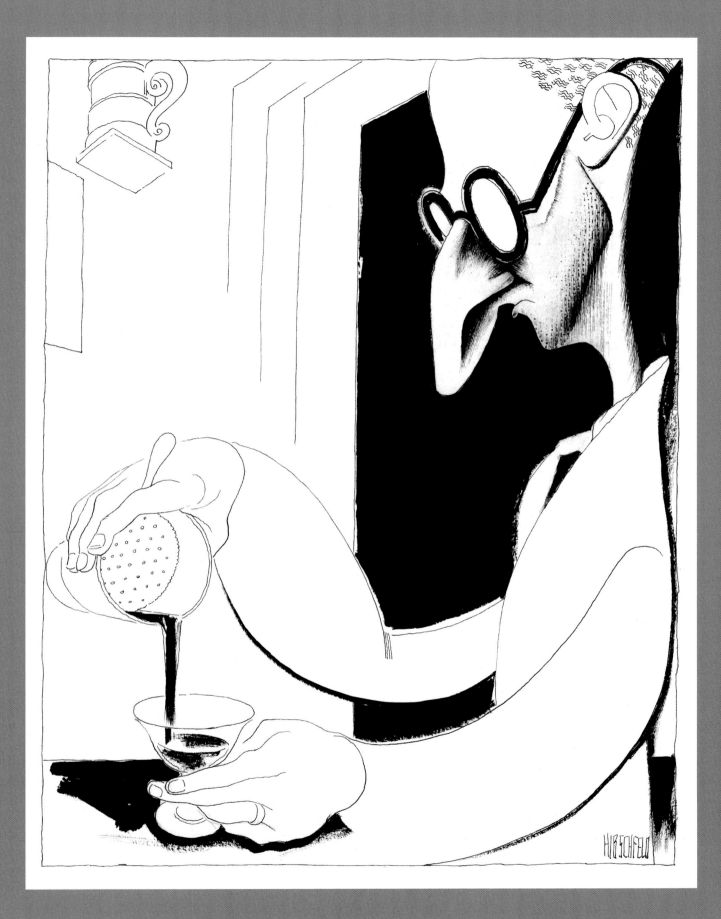

Joe

The Dixie

One of those quaint, old-fashioned places (circa 1925) which still thinks it needs a false front. In this case it's a cigar store, in the Forties, west of Sixth. No Masonic hocus-pocus at the portal. If the door isn't open, just press the bell and say hello.

The bar is spacious and commands a vista of noble mahogany, fine glassware, and old familiar bottles. The barkeep is John, and the kind of man you'd not hesitate to have your mother meet. He clamps down on drinks when he thinks a customer has had enough. Lends him taxicab fare if he's wasted his entire substance on the crater. Credit extended, not reluctantly, but with a pleasant wink, if one thirsts and the commission check is overdue.

The custom is of the better film, theatre and newspaper element which appreciates an honest drink in a wholesome atmosphere. A place where boasting comes easy, and where listeners are tolerant. An occasional drink is on the house; the invitation to have one at the proprietor's expense is given gracefully.

The brandy would be a bargain at a dollar. Priced here at fifty cents. The beer is better than the average slop, at a quarter, on draught. Far better is the bottled brew at fifty cents.

Specialties are the coolers, like Tom Collinses and rickeys.

Open house, with beefsteak, all the liquor a gentleman can hold properly and cigars, is frequently held. Asking for a bill on these nights is an affront to the management. A direct insult, sir.

John Advocates:

ROCK AND RYE

One teaspoonful of rock candy syrup or grenadine, juice of $\frac{1}{2}$ lemon, one glass of rye whiskey. Stir together in the same glass and squeeze lemon peel on top.

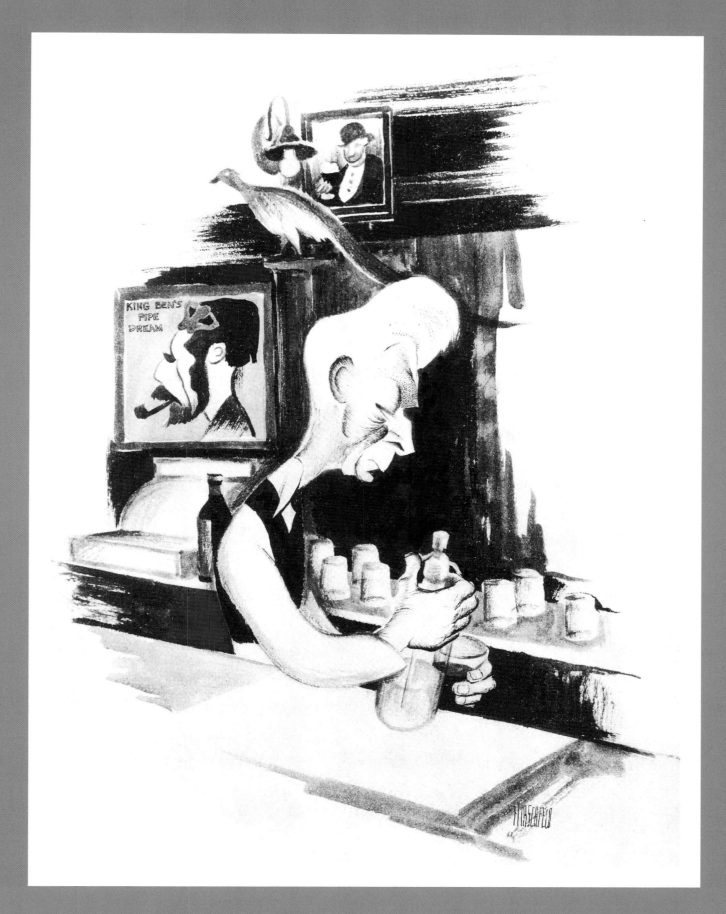

John

The 163 Club

Brazen little sub-debutantes, smelling of Chanel No. 5 and Mitsouka filched from their mamas' (accent on the second syllable) atomizers. They're held in the concupiscent grips of their young partners on whose aristocratic pans "acne vugaris" is just beginning to break out.

The son of a Methodist United States Senator punishes his daily fifth of red-eye here with the same pathetic zeal with which his booming ancestor larrups the Pope at Rome.

One-six-three is the house number, but that's all you'll be told in this deposition because you won't like the place after the first visit anyhow.

The bartender answers to the name of Roma. He scowls, but not because he's ill-mannered. It's because the place has never been raided and he worries about what's going to happen to him when the centurions from Washington finally crack down on the place.

The red-eye is fifty cents and surprisingly good, but none too neatly served, and no such thing as a bottle on the bar so that the customer may help himself. These Tripler betogged boys can make little pigs of themselves sometimes. The beer is oddly priced at thirty-five cents and the usual swill that independent places have to take or else —.

Most of the wall area is covered with framed covers of "La Vie Parisienne," the subjects showing little variation on the usual pornographic theme.

Dime egg sandwiches are fetched from a delicatessen on the corner and priced fifty cents when they reach the table.

A hot place, yet, paradoxically, not so hot.

Roma Guarantees:

LEROI COCKTAIL

One yolk of fresh egg,
⅓ curaçao,
⅓ brandy,
⅓ sloe
gin, one
teaspoonful
raspberry
syrup,
one
teaspoonful
cream,
½ teaspoonful
of lemon juice.

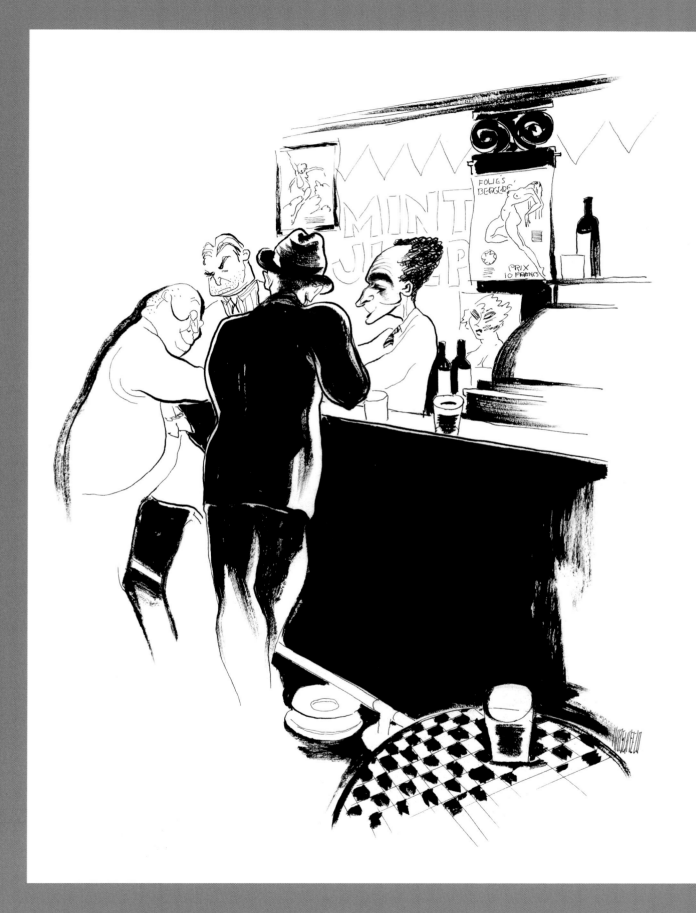

Roma

The 19th Hole

A nice hideaway for bond salesmen and their customers' wives. Discreet French and Swiss waiters who know how to draw a wine cork. Real privacy in the private rooms. No booze fighters but usually a number of debutantes who seem to like drinking for the sake of getting a morbid, ritzy jag on.

The barman, Paul, is a specialist. He hasn't been here long enough to recognize and thereby lose his native respect for the American rotter. He speaks an interesting variety of servile English and mixes a cocktail with loving care. One of the few who knows enough not to use quick-melting shaved ice in a drink.

Paul's not especially adept with gin drinks, but he's careful about the proportions, putting in less spirits rather than too much, for which he should be admired.

The wines run as high as thirty dollars a quart for the vintage stuff. Few straight drinks are sold. Cocktails of the better-known categories are a dollar. "Pousse Café" and other alcoholic confectionery higher.

No hors d'oveuvres in the bar and most people don't miss them. But they're wheeled to the table in the main dining room and a de luxe assortment they are.

The food is of cordon rouge quality. The "poulet en cocotte" is a specialty.

A minimum of drinking at the bar; the absence of music and the fact that men with flushed skins of healthy gourmets may be seen mixing their own salad dressing is evidence that the 19th Hole has "ton."

Paul Prescribes:

FLU COCKTAIL

One dash of Jamaica ginger, one teaspoonful of lemon juice, one teaspoonful rock candy syrup, one teaspoon ginger brandy, one glass of rye whiskey. Stir together and serve in same glass.

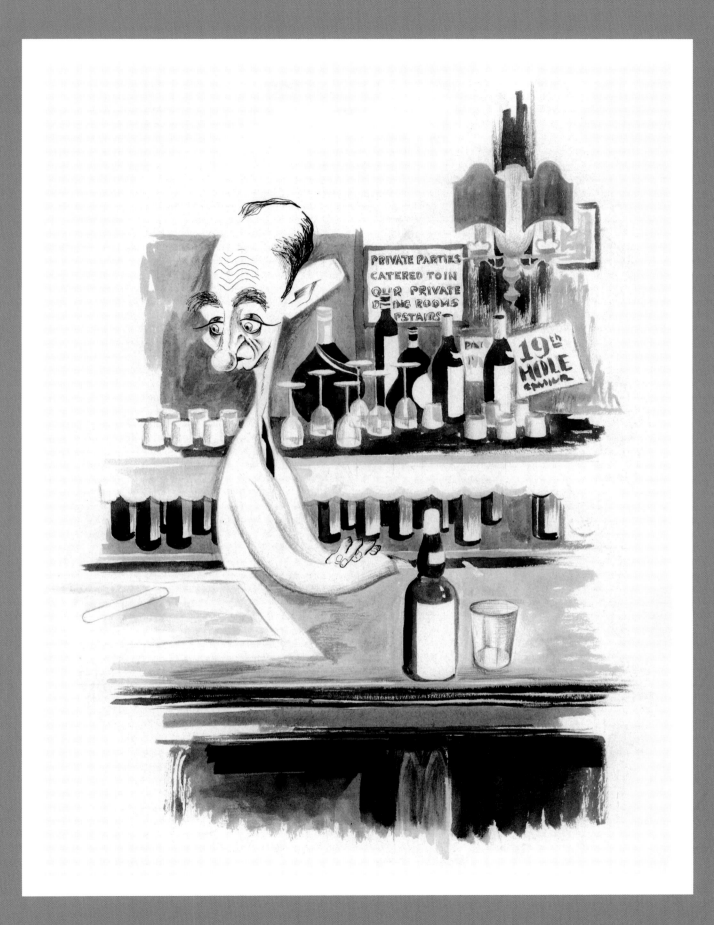

Paul

Old-Fashioned Club

Nothing that the name of this place, on Fiftieth, west of Sixth, implies except that every third drink or so is on the house.

The room is plain and square, once a loft over a garage. The walls are beaver board. The ventilation leaves much to be desired. The "art gallery" consists entirely of pictures of musical comedy persons and scenes, donated by the press agents of extinct musical comedies.

The pride and joy of the management is an atrocious clock, framed with an elk's head and B.P.O.E. slogans. The actual clock part of it is forever wrong. Still this object is kept under glass.

Frank, the bartender, is a specialist with the drink of the house, the Old-Fashioned cocktail. A pleasant fellow who doesn't bore the patrons and mixes the American type of cocktails much better than the average member of his craft. His offer of one on the house is done gracefully and with tact.

The free lunch is well cooked and cleanly served. There is a choice of a tender roast of prime beef or tasty, pinkish Virginia ham.

An out-and-out drinking establishment with no pretentions to "atmosphere." The beer is sometimes good, at a quarter, and sometime atrocious. When the latter is the case, which is often, the excuse is, "Bad barrel today, boys. We gotta take what they give us." Which, indeed, is more truth than poetry.

The hard liquor is fifty cents and worth seventy-five. Cocktails cheerfully made and sold at half a dollar. The outer-fringe of Broadway; horse-players, small gamblers and the better class of unemployed are the frequenters.

A place where one who wants a drink without scenic trimmings can get it with dispatch and without ceremony.

Frank Recommends:

OLD-FASHIONED COCKTAIL

Take a small tumbler and put into it four dashes of angostura bitters, one lump of ice, one glass rye whiskey, one tablespoonful powdered sugar. Stir well, until sugar is dissolved. Squeeze lemon peel on top and serve in same glass.

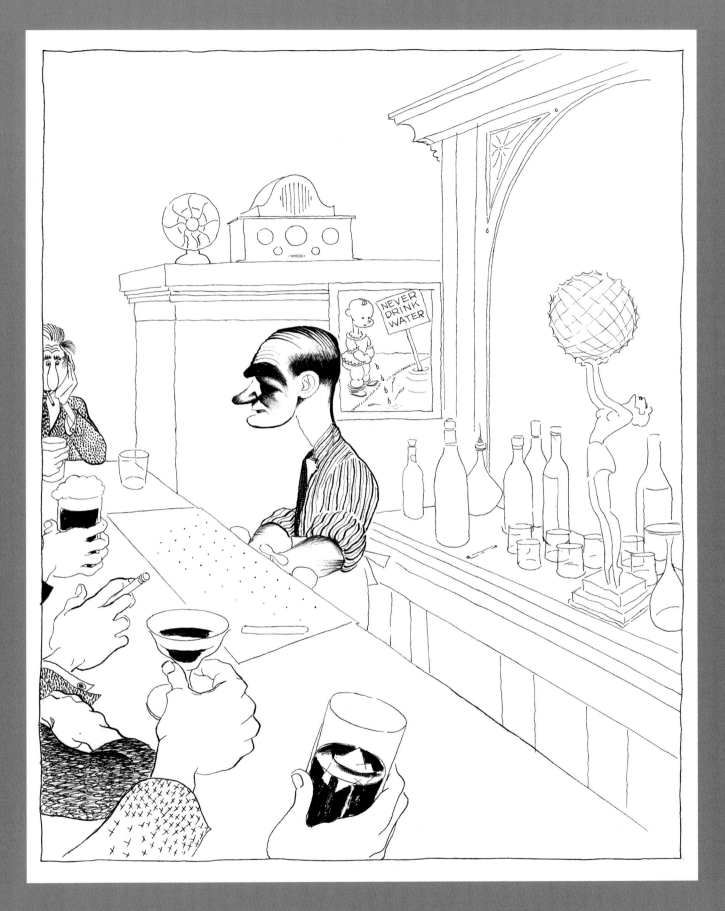

Frank

George's Place

A businesslike drinking-place for purposeful drinkers, who like the jolt of a stiff drink and have no time nor inclination for the social life of the speakeasy.

It's on Lexington in the Thirties *(507 Lexington Ave.)*. Street entrance and no questions asked. A bit of cautious peeping through chintz curtains when the customer gets upstairs.

Women in their late thirties, who learned to drink ten years ago, like this place. Many of them are straight-rye-water-chaser drinkers who drop in three or four times a day.

Open at nine o'clock in the morning to catch the pick-me-up drinkers. Bustling between noon and one o'clock and late in the afternoon.

The owner is a Chinaman who looks sorry for those extremely polite patrons—those with that lush red look about their lips, denoting that they have been drinking hard and steadfastly for many years.

Plain, green baize on the walls. A few photographs, one of Sir Thomas Lipton drinking beer.

George is the bartender and one of the best in his craft. Expert, but not showy. He keeps his distance. He uses no green crème de menthe—only the white—a dash of it goes into almost every gin drink he makes.

Seventy-five cents buys anything but wine. The beer is the same slop that the racketeering brewers are making them all buy. The hors d'oeuvres are fresh and of high grade.

George Heralds:

GEORGE'S SPECIAL

½ gin, ¼ apricot brandy, ¼ lemon juice. Shake well and serve in cocktail glass with cherry.

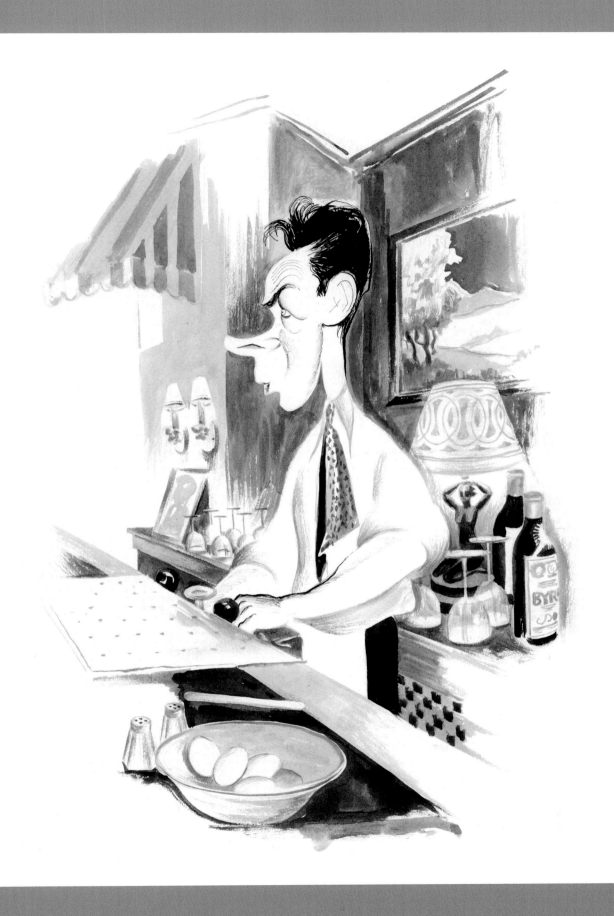

George

Sam's

It has ever been Sam's way to locate his places where entrance entails wading knee-deep through a welter of little Italian boys. Charming little fellows who know all the nasty words in the truck-driver's lexicon. Up a dingy flight of stairs, through a battered door with "Pasquale is Rosies feller" chalked on it.

It's on the tag end of MacDougal Street and hasn't its peer in this section of downtown. The room is large, nicely lighted and not overdressed. The dancing space is ample, and the booths for drinking are spacious and comfortable.

The service is superior to that which prevails uptown. The liquor, too, a shade better.

The bartender is Tom and he hasn't much traffic with the customers. The management prefers, and so will the patrons, after a while, that drinks be served at the tables.

Frequented not by Greenwich Village folk, but those with some sentimental memories of the place. Fiction magazine editors, minor executives who took postgraduate work in light love-making in these purlieus; a lot of young men with crisp, black mustaches, all called "Doc." They're dentists and not to be taken seriously.

The cuisine is exceptionally good—for the Village. The London broil is especially commendable. Chinese specialties by a native chef.

Good whiskeys are fifty cents, with liqueurs the same, and cocktails begin at that price, ranging upward. Beer is twenty-five. Music is by automatic gramophone, and there is no curfew.

Tom Appraises:

MARTINI COCKTAIL

⅔ gin, ⅓ French vermouth (orange or angosutra added if required). Shake well and strain into cocktail glass.

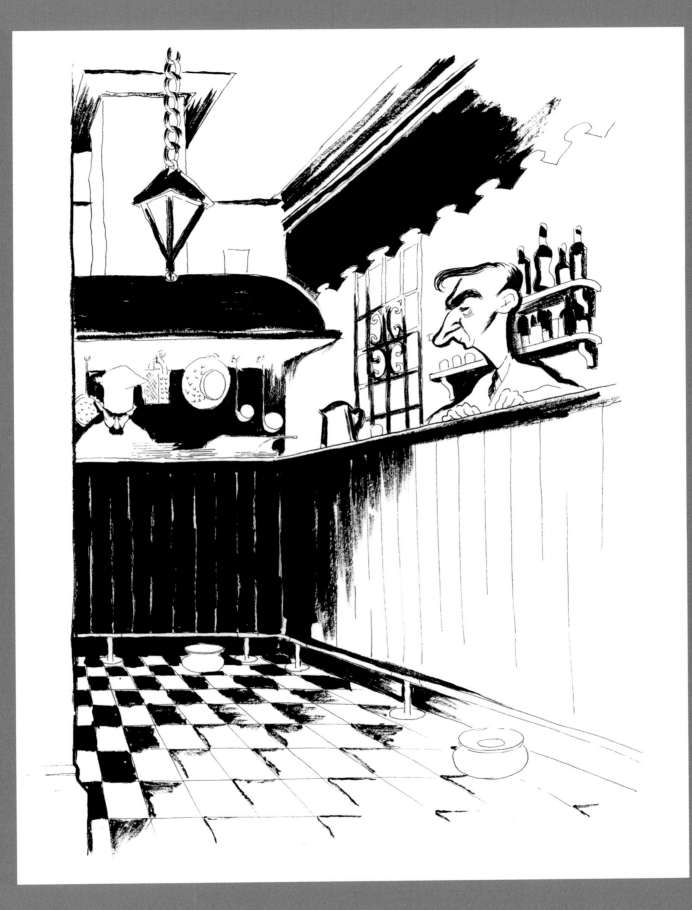

Tom

The Irish Veterans Association

As wide open as the Pampas and as aromatic as an empty soy-bean barrel.

It's on Lexington Avenue in the Twenties, near enough to the 69th Regiment Armory for the noble guardsmen to dash over for a quick one after drill.

The tone and "decor" strictly Hibernian. Potted shamrocks. Green and yellow Irish flags, blackthorn shillalahs, and clay dudeens tied with green ribbon. Al Smith's picture festooned with a grimy Free State banner.

The clientele is divided between the members of the National Guard and the employees of Bellevue Hospital. A steady customer is an employee of the City Morgue who gets insulted when anybody calls his charges "stiffs." He like to call them and have them referred to as cadavers.

A soggy bowlful of pretzels comprises the free lunch.

Not a drop of Irish whiskey in the place. Beer of a fairly decent grade, only slightly needled, retails at a quarter. Drinks, straight or high balls, at double that.

The bartender is George. He's morose and rarely joins in the conversation of his customers. He has never made anything more complicated than a whiskey sour, and that, inexpertly. The bitters bottle is there only for show.

One feature of the I.V.A. is that every second drink is on the house.

If you hate piping Irish tenors who think they have voices like Morton Downey, singing "Mother Machree," this is a good place to avoid.

George Offers:

WHISKEY SOUR

Teaspoonful sugar, juice of $\frac{1}{2}$ lemon, one glass rye whiskey. Shake well, strain into tumbler and fill with syphon. Decorate with fruit.

72

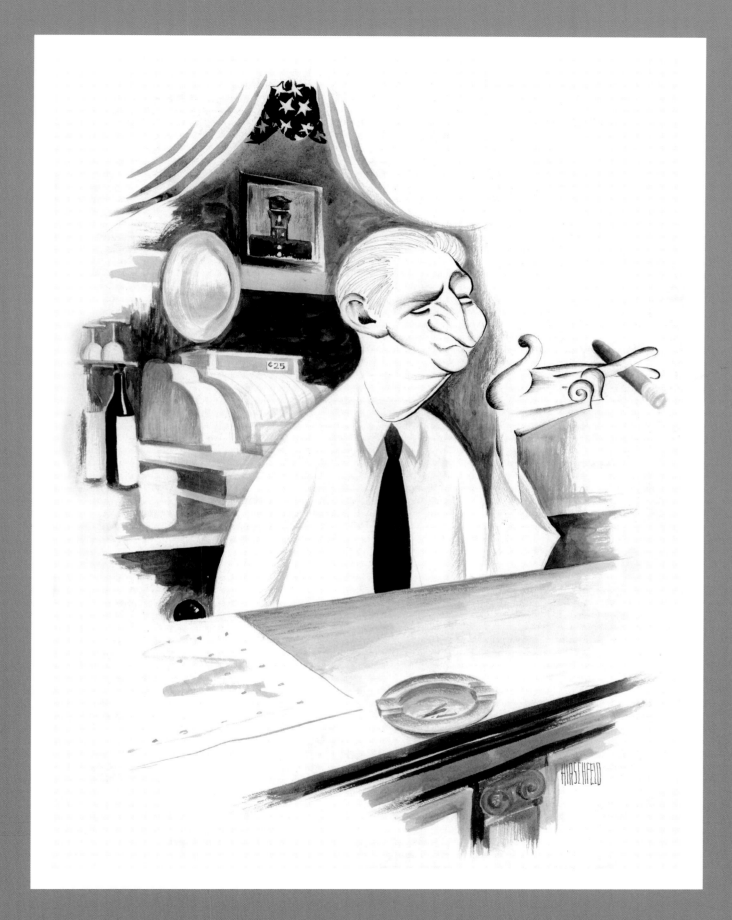

George

The 44th Street Club

Take the stairs if you'd rather, but the elevator boy will cheerfully take you up the three stories and tell you which door in this office building, housing music publishers, small-time booking agents, and mail order promoters, leads to the Club.

Harry is the bartender. Middle-aged, expert and an agreeable conversationalist. There's little doing before one o'clock in the afternoon and not much more after six in the evening. The custom is mainly from among the tenants in the office building *(405 W. 44th St.)* and their clients. The occasional hoofers, saxophone players, and other musicians are referred to by the barkeep as "talent."

Large windows on two sides let in sunlight, a rather unusual commodity in beer parlors, imparting valuable actinic rays to the drinks. Physicians say it's good for you.

A wholesome informality prevails. Nice smells from the open kitchen and the gleaming copper pots hanging from hooks over the range are a pleasant sight.

Harry, on invitations to have one on you, will accept a small beer. He'll return the favor again and again.

Beer is fifty cents and more than merely palatable. On second thought, it is downright good.

Whiskeys, brandies, and your choice of cocktails are likewise four bits and even better than the beer.

The radio remains on for market reports and sporting news the entire day. Knob ungrudgingly twirled on request if you prefer music.

The refreshments are excellent, as are the potato chips, fried on the premises.

Booze fighters are not welcome.

Harry Sponsors:

STINGER

½ white crème de menthe, ½ brandy. Shake well and strain into cocktail glass.

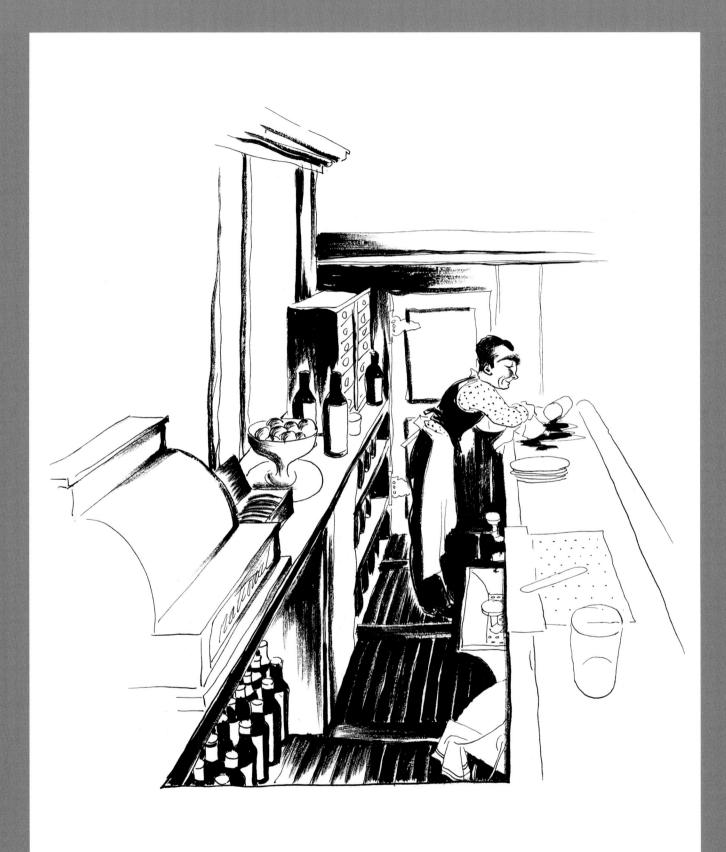

Harry

Gus'

O nce a distinguished-looking private residence, an interior decorator dealt it a slap in the façade with a tequila drinker's nightmare of polychrome "torchères" and synthetic red tile.

Reconciliation to the mock adobe walls and the strings of papier-mâché peppers comes after the fourth drink. The second if you take the specialty of the house, the mint julep.

It's in the Fifties, east of Madison *(112 E. 52nd St.)*, and thereby hangs its Sutton Place patronage. There's a girl at the door, and she's harder to get by than a Roxy usher when there's a long line waiting. So better have your card.

The bar adjoins a small dining room on the lower floor, thanks be. The upper story is given over to a large dining hall and smaller private chambers.

The food is properly cooked and intelligently seasoned. The menu is varied, and most of the dishes go well with bottled ale.

Arnold is the bartender. Quick, efficient. Not much of a conversationalist. It would do the place no hurt if he were a bit more ceremonious in the blending and serving of the julep.

For some reason, unknown to this deponent, it is popular with the opera and concert-going crowd. The humming of arias and the tootling of cadenzas are sometimes painful. So come before eight.

The refreshments at the bar are edible, no more. The grain liquors are potable, at a dollar. Ale is what you get if you ask for beer, also a dollar. The juleps are a dollar-fifty.

Arnold Volunteers:

MINT JULEP

One teaspoonful of sugar, $\frac{1}{2}$ wineglass of water or soda, three or four sprigs of fresh mint. Crush until flavor of mint is well extracted; then take out mint, and add two glasses of Bourbon whiskey. Fill tumbler with fine shaved ice, stir well until glass gets frosted, then take sprigs of mint and insert them in the ice with stems down- ward so that the leaves will be on the surface in the shape of a bouquet. Add slices of orange, lemon, pineapple and cherries on top.

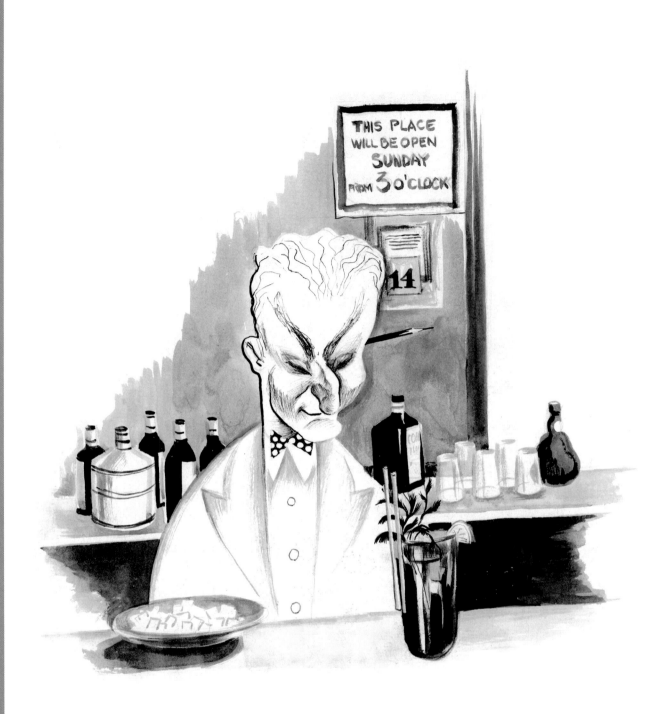

Arnold

Ship Ahoy

Don't expect to feel like Gaugin or a beachcomber amid these frescoes of coral atolls, palm trees bending like narcissi over lagoons, and hula girls without hips. Baring your chest, rumpling your hair, and calling for a bottle of squareface won't help the illusion. Because invariably a denizen of Tin Pan Alley will be torturing the black keys of the portable piano.

Pete, the bartender, hopes some day to say that a popular song has been composed in this establishment.

When the guests are too much annoyed by the circumambient piano, the radio is switched on and forgotten.

The chairs are comfortable, the beer seemly, and the lighting, by accident or design, neither too harsh nor too dim.

Look for Ship Ahoy in the Fifties, near Fifth *(52 W. 51st St.)*. Cross the gangplank from the sidewalk into the dining room. Better scoff first because the bar is for drinking exclusively.

Near a battery of telephone booths is the barroom door. Say "the Captain" sent you, and there'll be no questions asked but, "What'll you have?"

The mixed and straight drinks are seventy-five cents. Pete is a good hand with the shaker. Beer is on draught, at thirty-five cents, and as good as the fifty-cent brand dispensed elsewhere, which isn't any too potable. Occasionally bottled brew at seventy-five, worth fifty.

Supported almost entirely by residents of their neighborhood; the type that lives within hearing of the Sixth Avenue elevated train, but whose street addresses sound important. Chorus girls, "walk-ons" at Theatre Guild productions, and occasionally an amusing group of the famous middle-sex regiment.

Pete Acclaims:

HORSE'S NECK

Peel a whole rind of lemon, then put in a large tumbler, add a few lumps of ice, one teaspoonful of sugar, one glass of gin, then fill with ginger ale.

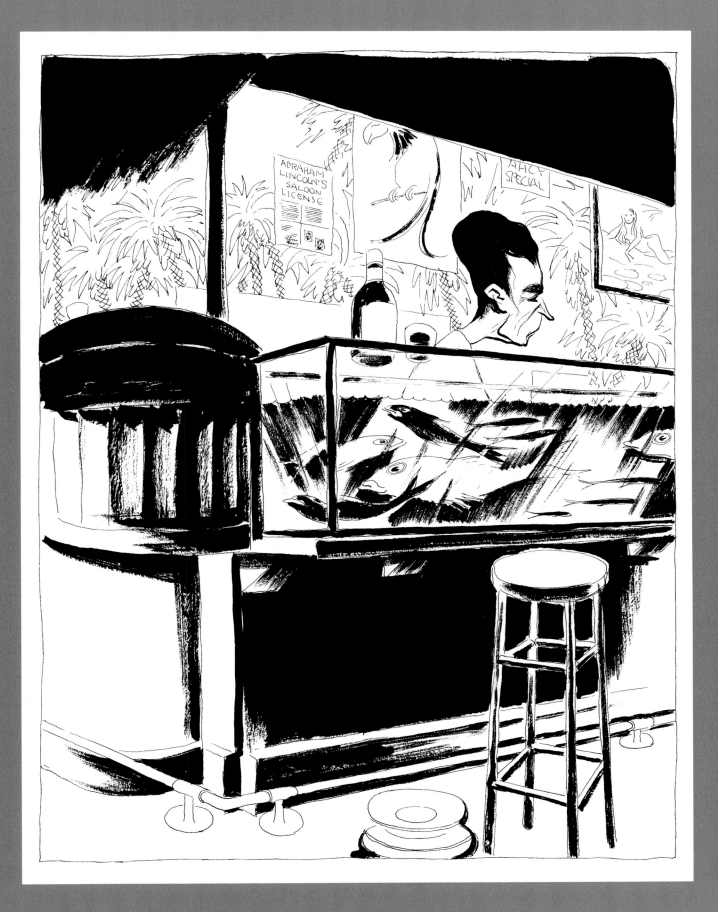

Pete

John and Jean's

Some day when the market nosedives, the wife is off on one of her nagging spells, the boy is cashiered out of college, and the girl friend starts being sisterly to a tenor, you'll want to go somewhere and swill yourself into a state of gossamer inanimation. This is the spot. Never open before dinner time, so don't bruise your knuckles.

You'll find it on Tenth Street *(139 W. 10th St.)*, or a cabbie near the Jefferson Market Court will be glad to convey you there. The entrance is upstairs through a Franco-Italian dining-room, then down again, this time the back way. No Villagers and their ways to bother a person. Don't mistake the attitude of Andre, the bartender, for sullenness. He is just minding his own affairs and keeping an accurate tally on the slate.

The booths are small, but comfortable, and no objection to propping up the bar if you prefer to pass out perpendicularly.

Some food before the breaking of the Big Drought is recommended. The spaghetti marinara is uncommonly good. The calf's head "vinaigrette" is toothsome, and the various "pastas" are not so filling as those elsewhere.

Nothing tricky about the "decor," and not attractive to youthful bibbers. A dimly lit back-parlor for those who like plain and fancy pawing with their drinks.

Bottled "red," tart and quick acting, is a dollar and a half, and a choice of dry white wines at prices not much higher.

Straight liquor is fifty cents. Liqueurs are the same. The brandy is magnificent. The Cointreau triple sec is prime, but it mixes badly with the northern distillates.

Even if you don't read French, there is a kick in the color prints of little Gauls polluting ponds.

Well, here's looking up your address.

Andre Ratifies:

QUARTIER LATIN COCKTAIL

One teaspoonful of Cointreau, $\frac{1}{3}$ Amer Picon, $\frac{2}{3}$ Dubonnet. Shake well and strain into cocktail glass.

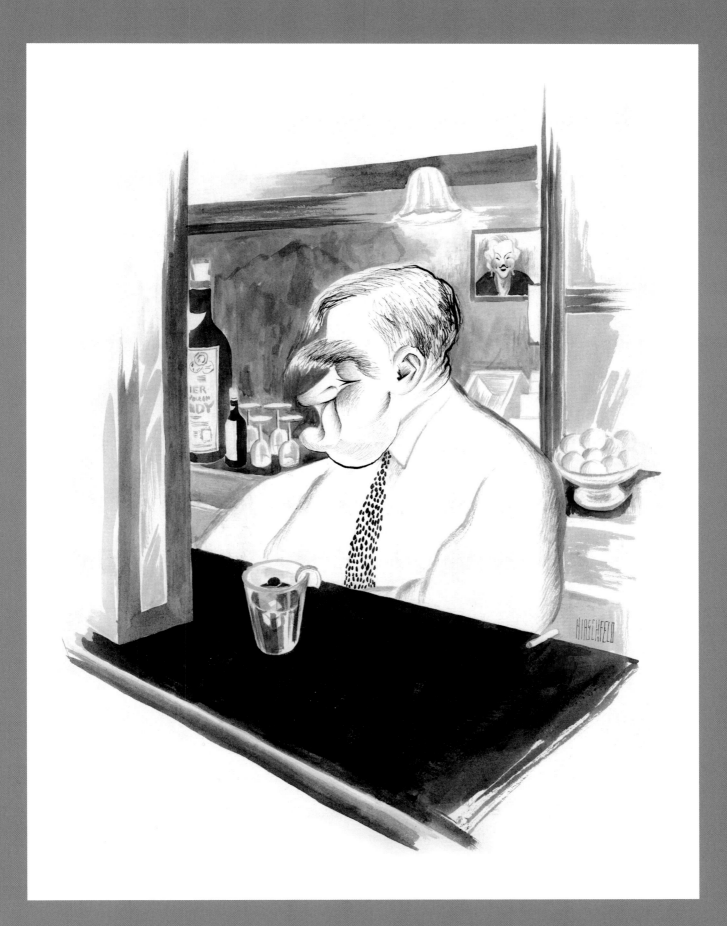

Andre

The Roxy Grill

A doorman, who is reputed to spot a Revenue Man by instinct, performs the really unnecessary surveillance at the grill. That stuff went out years ago.

In the West Forties *(155 W. 46th St.)*, the entrance is through the hall of an office building. A thoroughly masculine establishment. One of the best in mid-town for those who like conviviality, safe liquor, and cold if slightly needled beer.

Press agents, theatrical trade-newspaper men, and junior film company executives swear by this layout. Pete, the barman, is about forty-five, a shrewd fellow, and a good conversationalist. His remarks on business conditions generally have a way of being prophetic. He knows a man's first name after the second visit. He mixes drinks with the éclat of a cocksure stage magician.

Most of the drinking is done in the narrow stalls opposite the bar. The free lunch is plentiful and exceptionally good. An assortment of olives, pickles, cooked and preserved fish may be had. There is rosy Virginia ham, two varieties of hot soup, and three of vegetables. A boy brings any or all on demand. Free lunch chislers who put both feet in the trough on a single glass of twenty-five-cent beer are frowned out of countenance and out of the place by the doughty Pete.

Women rarely enter the bar and are never seen standing at it. For them there is a parlor, which also does duty as a repository for crying drunks.

Pete Commends:
DUBONNET COCKTAIL
⅔ Dubonnet, ⅓ gin.
Shake well and pour
into cocktail
glass.

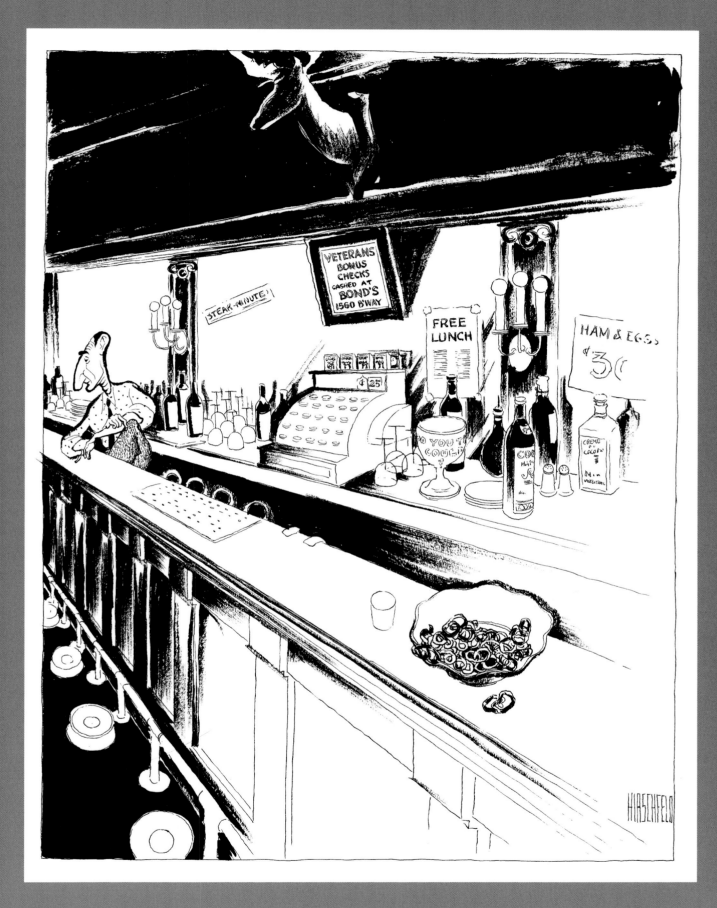

Pete

The Little Maison Doree

Inspired by Alice Foote MacDougall's Neo-Iberian interiors, even to the serapes draped over false balconies. Beloved of accountants and those moderately salaried white collar workers who call themselves office managers. They come there with their wives to celebrate anniversaries.

Cards of admission are issued, but scarcely ever asked for. Suspicion is attached to those who insist on showing them. Look for it in the Fifties, west of Sixth *(72 W. 52nd St.)*.

The dining-room, off a sleazily decorated foyer, is comfortable and not overcrowded with tables. This is for the casual uninitiate who isn't aware that he can get wine with his seventy-five cent luncheon or the dollar-fifty dinner.

The bar is small and never crowded. Eddie is the bartender. He's deft but unsociable, which is just as well. Dinner is served in the barroom, too, and with somewhat more éclat by waiters who understand French.

The mixed drinks and the straight grain liquors are seventy-five cents. There is scant demand for the beer, which is bottled, at a dollar. This is better than the average, as local brews go. The liqueurs and brandies are first grade. Considerable respect is shown the person who demands a frappe.

Wine can be had at two dollars the flagon, and note well that it is served in the original container and not decanted from a keg into a coffee carafe.

The dinner is table d'hôte and is cooked with Gallic touches of garlic. It's worth wading through for the sake of the demi-tasse and a "fine."

Eddie Fancies:

ABSINTHE FRAPPE

⅔ absinthe, ⅓ syrup of anisette, double quantity of water. Shake until the outside of shaker is thoroughly frosted. Strain into small tumbler.

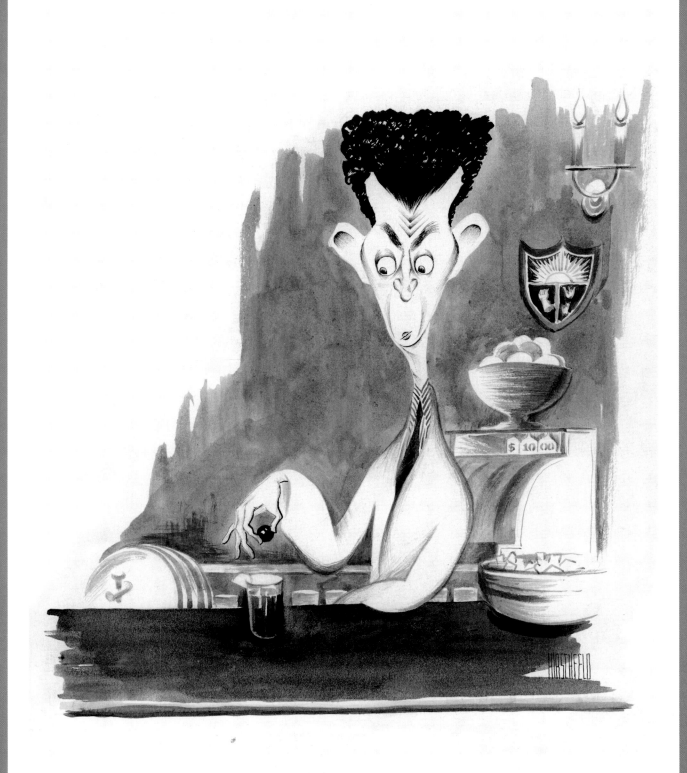

Eddie

Club Napoleon

Three similar plants challenge its right to be called the best spot in New York. But none are there who do not yield to its claim as the gayest of oases on Manhattan. It's housed in the finest looking mansion in the Upper Fifties, just west of Fifth *(33 W. 56th St.)*.

The doorman is instructed to vise a card. But a fat, juicy name like Morgan, Vanderbilt, or Rockefeller awes him into pressing the "O.K." buzzer.

The entrance hall is all gold and ivory, liberally mirrored, something the ladies appreciate.

The floor above has the bar and dining room. In the former a salon orchestra which seems to be forever playing either "In the Luxemburg Gardens" or "Weiner Blut." More interesting are the two colored boys with the push-about piano. Their rhythm is catchy, and those who care to hear porno-parodies of the latest song hits can have them crooned softly and insinuatingly.

The bar is manned by four experts with Harry as the head man. Trained in the Continent, he knows his manual and blends a perfect drink if you show the least signs of being critical of straight stuff.

Nothing sophisticated about the habitués. They're mostly theatrical folk who are up on the columnistic gossip because it's about them. Musical comedy leads of both sexes; sycophantic real estate men who like to be seen with theatrical people; sub-sycophants, and Joe Russell. Anything ridiculous or bizarre is likely to happen here, and frequently does. There are no dull nights, and none of the horseplay is ever violent. The waiters have their own cute way with an errant contemptible.

The dining room is superb, the paneling that the nabob who once owned the house had put in, is still there. The food is excellent. The prices steep but not prohibitive. A Chateaubriand steak as is a Chateaubriand steak may be had. Drinkables are a dollar straight. Several ales, priced the same.

Oh, you'll come back.

Harry Presents:
CHAMPAGNE COCKTAIL
In a wineglass put one lump of sugar, saturate with angostura bitters, add one lump of ice, fill the glass with champagne, squeeze a piece of lemon peel on top, stir, and serve.

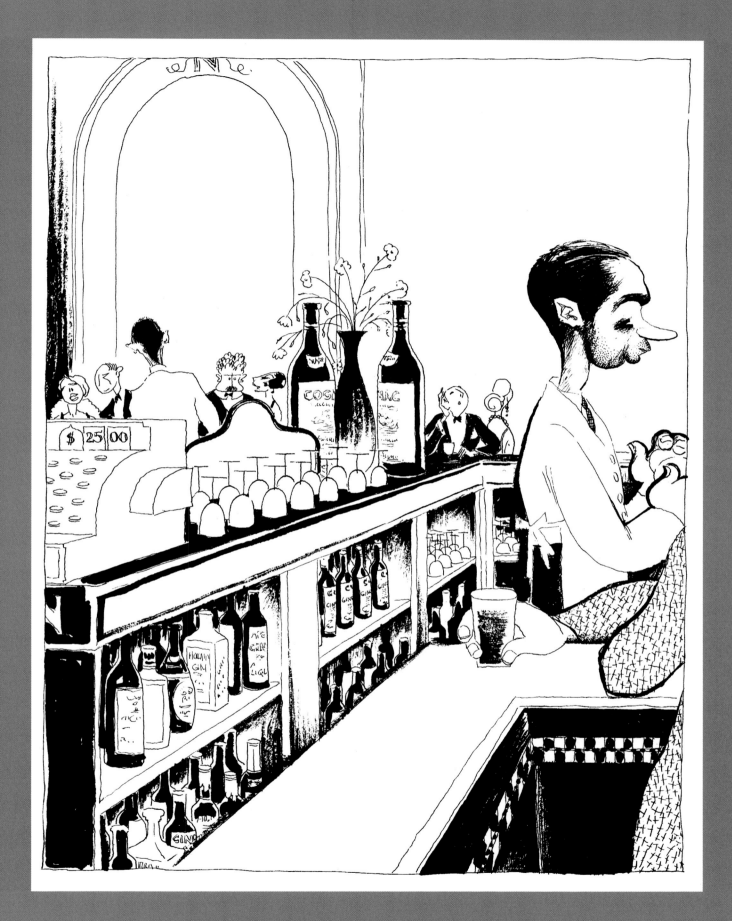

Harry

The Press Club

Tabloid newspapermen must have somewhere to cash checks, and this is as good as any. Better than most of the reporters' haunts downtown. In the Forties, east of Third *(141 E. 46th St.)*, and up a short flight of stairs. No raids because they're really careful, but a turned-down hat brim and a drooping cigarette will pass anybody.

Entrance is directly into barroom. There are no tables here, but the adjoining dining room is comfortably laid out. Good linen and clean silver.

The liquor is the McCoy, notably the Scotch whiskey which is reputed to be delivered through the connivance of influential ship-news reporters direct from Rum Row.

A stag's head looks down from the wall. Newspaper photographs of boxers, jockeys, hockey players, and Al Smith, some of them autographed, are the ornaments.

Johnny is both owner and bartender. He's expert, kindly and easy-going. Credit as high as $100 has been extended to working pressmen.

There's an electrically operated, nickel-in-the-slot target pistol that delivers a celluloid record of marksmanship.

The beer, at a quarter, is uncommonly palatable. Johnny's choice of cold, New York baked beans for the free lunch is a happy one. The beans have the charm of temporarily staving off hunger without sating it by dinner time.

The Franco-Italian food in the dining-room is excellent and moderate in price. The veal scallopini is cooked with real sherry and worth double the price.

Ladies are welcome. But they must be ladies.

Johnny Advises:

EGG-NOG

Fill the shaker half full of chopped ice, add one fresh egg, ½ teaspoonful of sugar, one glass of brandy, one glass of rum, the remainder fresh milk. Shake well and strain into medium-sized tumbler. Grate a little nutmeg on top and serve.

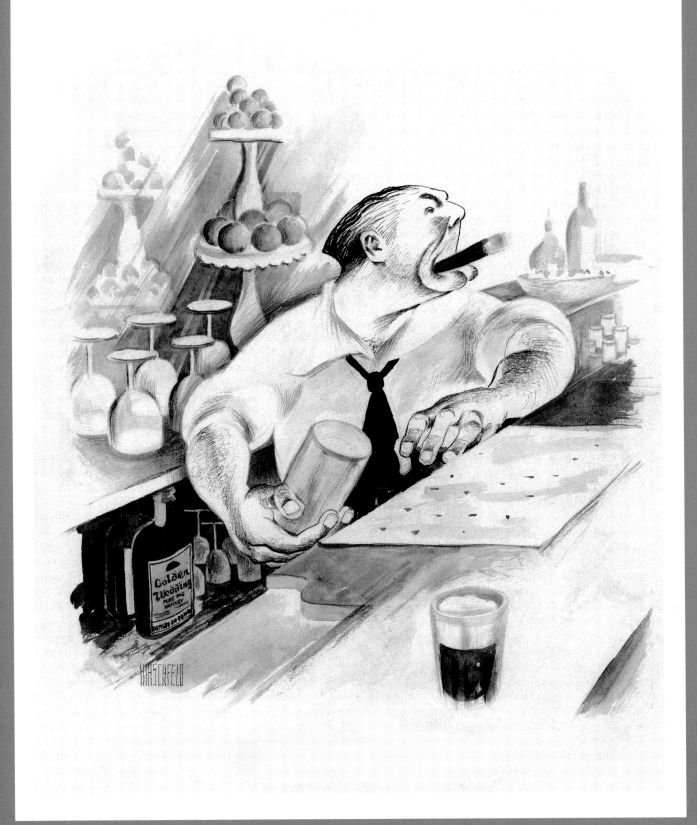

Johnny

The Place

The "Patsy" of the Broadway speakeasies. Somebody at the Prohibition director's bureau bears this place, in the Forties, off Sixth, a deeply rooted grudge.

Members of the nearby Friars Club who have exhausted their credit at the bar drink here. A dining room, paneled in sickly green wall-board, adjoins. Here chicken lobsters, forbidden by the Game Laws, and small steaks are featured. The immature crustaceans are hardly worth breaking the law over. The steaks often ought to be condemned by the Department of Sanitation. The tariff for a table d'hôte is a dollar, and it would be worth less except there's no skimping on the vegetables.

Jack is the bartender and he's proud of his bar, which was once a famous hotel. He thinks the Holland House. Not a nick in its hard surface. A beer glass will slide the length of the bar without tipping, if shoved the way Jack does it.

The liquor, retailing at seventy-five cents, is better than average. The beer, at a quarter, is rank. A free lunch bar offers a thick soup of bean or vegetable, often a crudely devised chowder, during the winter months. There are the inevitable radishes and onions and an unsanitary bar glass for the forks. The narcotic cheese wafers repose on the bar.

The film booking agents, independent publicity men, and actors form the three distinct cliques of its clientele, but hold no commerce with each other.

If you miss The Place the first time, watch for the door though which beer barrels are rolled in by the light of the moon or under the eye of the sun and two patrolmen.

Jack Proffers:

BRONX COCKTAIL

⅓ gin, ⅓ French vermouth, ⅓ Italian vermouth, the juice of ¼ orange.

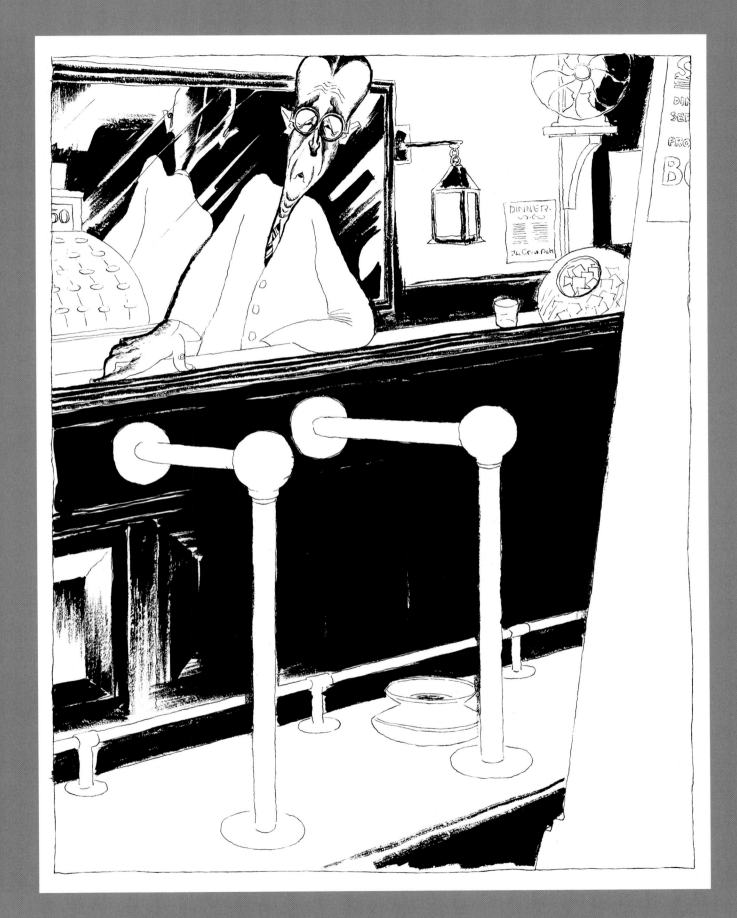

Jack

Gordon Kahn

Gordon Kahn, my father and Al Hirschfeld's collaborator on *The Speakeasies of 1932* (then entitled *Manhattan Oases*) came to America in 1908 from Hungary at the age of six, without a penny or a word of English. By the early 1920's he was a well-known New York newspaperman, fully at ease with the words and ways, the energy, style and creativity of Manhattan, from Harlem to Avenue C where he grew up.

Judging by some of the stories Al told me about their friendship in those days, he and my father had a hell of a good time.

There was the night, for instance, my father challenged the charlatan and restaurateur "Prince Romanoff" to a duel. Both men were notorious for wearing a monocle. Romanoff insisted Manhattan was big enough for only one of them. The honor, they decided, should go to the man who could flip his monocle in the air and catch it — no hands — with his eye. My father won on the first try.

Or the day Al and my father re-invented the sandwich as an entrée. The proprietor of a saloon called Dave's Blue Room wanted a gimmick to attract new customers. Gordon and Al suggested replacing the free bean sandwiches that traditionally accompanied a beer with a meat sandwich so thick you could tout it as a "meal in your hand" and charge a dollar for it. It went on the menu as the "Fresser's Special."

In the 1920s Gordon and Al also shared an admiration for the Russian Revolution. Al tempered his idealism with a visit to the Soviet Union. My father took his socialism to Hollywood as a screenwriter in 1930, where it thrived under the glare of the Depression and the Spanish Civil War.

While in Hollywood Gordon wrote or co-wrote forty screenplays, from westerns to society melodramas. Among the better known were *Whiplash, The Santa Fe Trail, X Marks the Spot, The Death Kiss, Ruthless, All Quiet on the Western Front, The African Queen* (the last two uncredited), and *The Cowboy and the Senorita* (Roy Rogers met Dale Evans on that one).

At the start of the Cold War in 1947, the House Un-American Activities Committee subpoenaed Gordon and eighteen other "Hollywood radicals" as suspected Communist Party Members. The studios fired the nineteen and refused to rehire them until they renounced their beliefs and surrendered the names of others the Committee could denounce. This my father refused to do. As a result, he spent the next fifteen years — the rest of his life — under a blacklist, unable to sell a word under his real name.

The red scare that began in Hollywood in 1947 destroyed countless families, reputations, and relationships, but not my father's life-long friendship with Al Hirschfeld. When our family lived in exile in Mexico, the two men stayed in touch by mail. When we returned to live in New Hampshire in the mid-1950s, my father was often a guest at the home of Al and his wife, Dolly, on Manhattan's upper East Side. My father's happiest times were at Al's New Year's parties, full of friends from those salad days in New York like S. J. Perelman, Zero Mostel, Alexander King and Ogden Nash.

My father was about to embark on another one of those parties when he died of his third heart attack, early in the morning of December 31, 1962. He was sixty. He had called Al from New Hampshire hours before, to reassure him nothing would keep him from New York and to remind me, a randy college freshman, to be nothing less than a gentleman with Al and Dolly's lovely sixteen-year-old daughter, Nina, whom I had been visiting that afternoon.

One of the final entries in Gordon's diary mentioned his eagerness to greet 1963 in New York. The next page contained a list of the magazine articles he

had been able to sell that year under the pseudonym he'd used since the Blacklist, "Hugh G. Foster." As Foster he wrote fiction and nonfiction for *Esquire, Playboy, Holiday*, and others. If all the checks cleared, his income for 1962 would have been $650. (A novel he had written in Mexico, *A Long Way from Home*, to which he'd proudly attached his real name, would remain unpublished for another twenty-five years.)

Gordon would have been delighted to know that Al lived to be nearly a hundred and died, like Einstein, with a pencil in his hand. He used to tell me that Al's father, who died in his 90s, had learned the secret of a long life — always leave the table a little hungry, with something still on your plate. Al, he said, turned that advice into an artistic principle — taking only what was essential from a character, the truth and beauty of its line.

Gordon, in fact, was one of Al's subjects. My family has a small oil painting of him Al did when they were roommates in the early '20s. You can also find Al's caricature of him in this book. He's the scrawny fellow with the shy smile and stubbly head at the bar at Jack's on page 33. In both works, Al caught a deal of my father's essential social self — his critical eye, abundant energy, and hint of a smile. What lie hidden, except for those who knew him, are the qualities that made him a remarkable writer and friend — his compassion for others' misfortunes, his sense of humor about his own, his indomitable Socialism, and his absolute delight in finding, as did Al, the perfect line for describing what he saw.

I'm sure it would have tickled Gordon to know that the book he and Al had done together when they were young might stand the test of time. The idea that it would be republished seventy years later — and maybe even turn a dime — would have had him giggling with glee.

—Tony Kahn

HIRSCHFELD'S HARLEM

INTRODUCTORY ESSAYS BY WILLIAM SAROYAN AND GAIL LUMET BUCKLEY

9 x12, 148 pages, $75 cloth
ISBN: 1-55783-517-9

HIRSCHFELD

"Al Hirschfeld's drawings are to caricature what Fred Astaire was to dance."

—JULES FEIFFER

No artist ever captured Harlem's dangerous highs and bluesy lows like this Master of the Performing Curve. Hirschfeld began his artistic odyssey six decades ago, charting that legendary New York neighborhood's special rhythms and moods in splashy, feverish hues.

Hirschfeld's Harlem opens onto a special portfolio of these full-color works, a pictorial essay of the Swing Era. **Quincy Jones, Whoopi Goldberg, Lena Horne, Geoffrey Holder, Eartha Kitt, Bobby Short, Brian Stokes Mitchell, Dr. Rev. James Forbes, Dr. Howard Dodson, Carmen de Lavallade, Charles Rangel, Ossie Davis, Arthur Mitchell,** and other Harlem artists and dignitaries supply accompanying commentary, reminiscences, and analysis—each voice focusing on one portrait.

Then it's back to Hirschfeld in his signature black-and-white takes on forty Harlem artists and public figures—Duke Ellington, James Earl Jones, Ethel Waters, Cab Calloway, and Gregory Hines among them—all caught in the creative act by one of our greatest artists.

Each drawing is accompanied by a thumbnail narrative by Hirschfeld about the most famous inhabitants and transients of these fabled streets.

Hirschfeld's Harlem opens a picture window onto nearly a century of African American artistry and life.

GLENN YOUNG

BOOKS

www.applausebooks.com